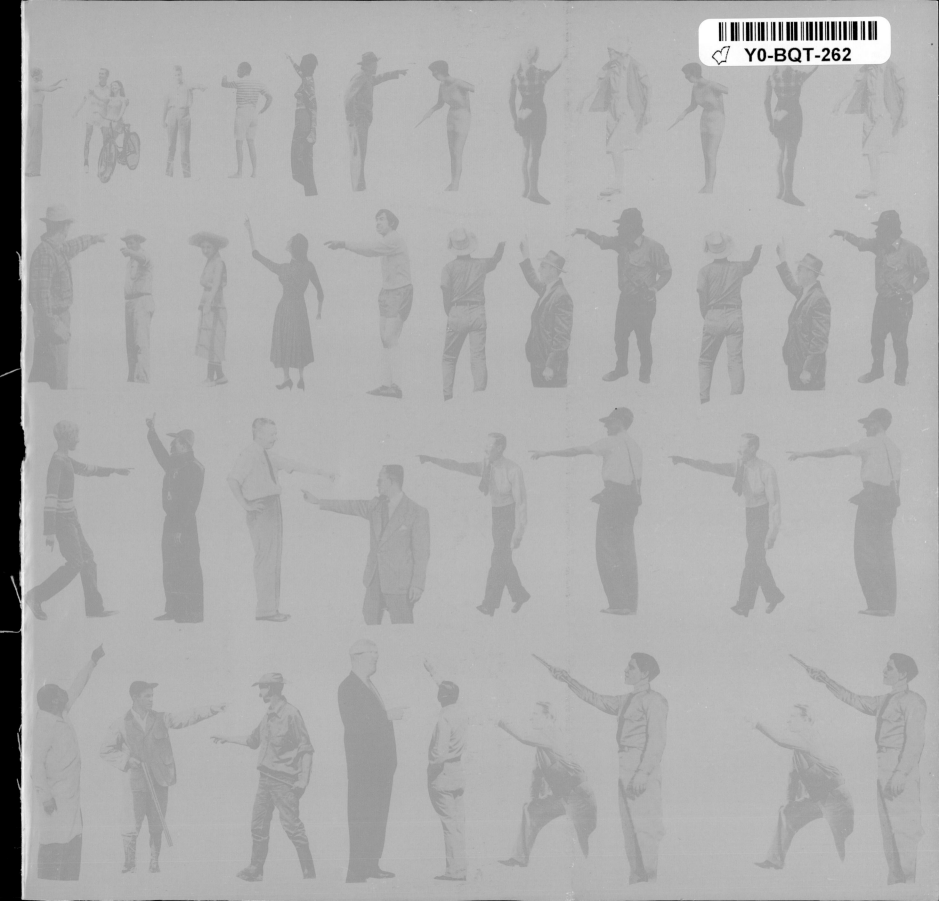

MARK TANSEY

MARK

Judi Freeman

TANSEY

with contributions by

ALAIN ROBBE-GRILLET

MARK TANSEY

Los Angeles County Museum of Art • Chronicle Books San Francisco

EXHIBITION ITINERARY

Los Angeles County Museum
of Art
June 17–August 29, 1993

Milwaukee Art Museum
September 10–November 7,
1993

Modern Art Museum of
Fort Worth
December 9, 1993–February 20,
1994

Museum of Fine Arts, Boston
May 11–August 7, 1994

Montreal Museum of Fine Arts
September 8–November 20,
1994

Copublished by the Los Angeles County
Museum of Art, 5905 Wilshire Boule-
vard, Los Angeles, California 90036, and
Chronicle Books, 275 Fifth Street, San
Francisco, California 94103

Distributed in Canada by Raincoast
Books, 8680 Cambie Street, Van-
couver, British Columbia, V6P 6M9

10 9 8 7 6 5 4 3 2

COVER: *Derrida Queries de Man*
(cat. no. 21, detail)

BACK COVER: *Four Forbidden Senses*
(cat. no. 4)

TITLE PAGE: *Close Reading*
(cat. no. 19, detail)

PHOTO SOURCES AND
CREDITS

Unless otherwise indicated, all
photographs are reproduced courtesy of
the lenders. A complete list of works
exhibited appears on pages 113–15.

Courtesy of Curt Marcus Gallery,
New York: cover, 21, 23, 27–28, 36–37,
40, 48, 50–53, 57–58, 68; Eli Broad Fam-
ily Foundation, Santa Monica: 15, 34–35,
47; Bruce White, 17–18, 22, 73–80, 82–90,
92–96, 98; Lynton Gardiner, 49; courtesy
of the Museum of Fine Arts, Boston, 55;
Peter Brenner, Los Angeles County
Museum of Art, 59, 108.

"A Graveyard of Identities and Uni-
forms," by Alain Robbe-Grillet, was
translated by Stewart Spencer.

LIBRARY OF CONGRESS CATALOGING-IN-PUBLICATION DATA

Freeman, Judi.
 Mark Tansey/Judi Freeman: with essays by Alain Robbe-Grillet and Mark Tansey.
 p. cm.
 Catalog of a traveling exhibition, which began at the Los Angeles County Museum
 of Art, June 17–August 29, 1993.
 Includes bibliographical references.
 ISBN 0-8118-0468-2
 1. Tansey, Mark. 1949- —Exhibitions. I. Robbe-Grillet, Alain, 1922-
 II. Tansey, Mark, 1949- III. Los Angeles County Museum of Art. IV. Title.
 ND237.T346A4 1993
 759.13—dc20 93-18853 CIP

CONTENTS

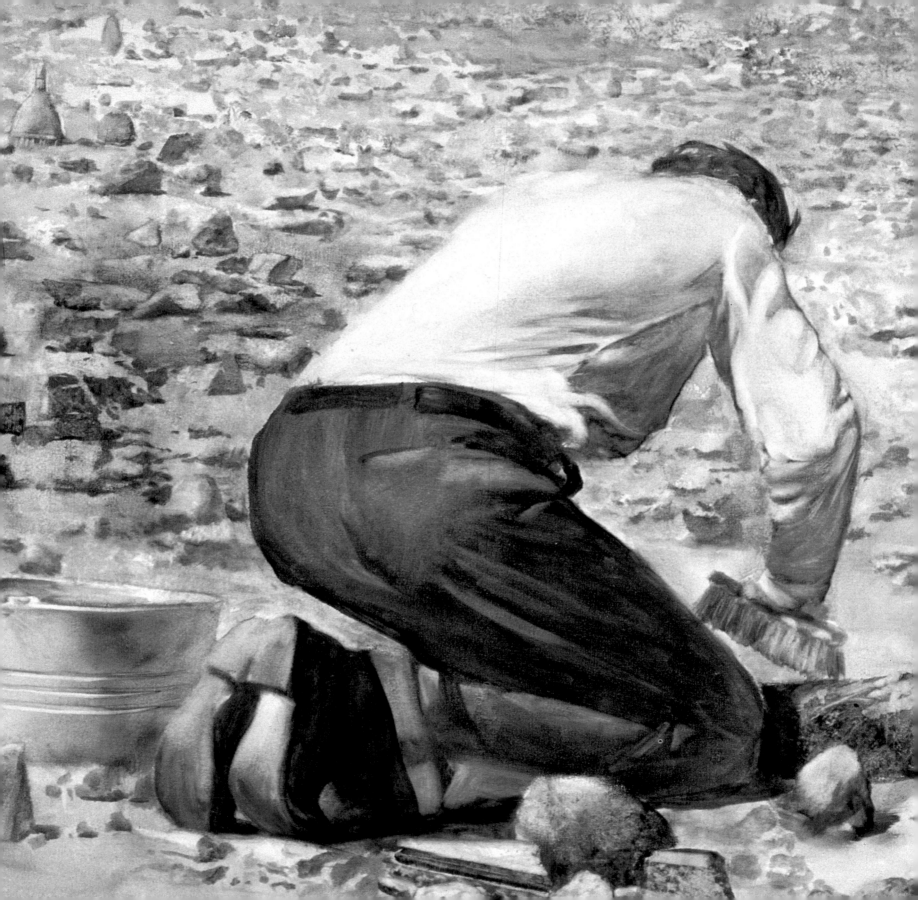

A GRAVEYARD OF IDENTITIES AND UNIFORMS

We ARE NOW IN THE DEPTHS OF A VERY hard winter of indeterminate date. As is his wont at the end of a lengthy journey, the pensive horseman sits lopsidedly on his white mare, leaning slightly to the left of the saddle, the progressive ankylosis of an old wound to his right knee having been made even worse by the intensely cold weather. He wears the glorious black uniform of a member of the crack cavalry school at Saumur, of which he was not long ago instructing officer. He appears to be lost, at least in thought.

Solitary and silent, he advances slowly over the freshly fallen snow, which is already hardened by the frost and which, to a constant depth of around four inches, covers the charred remains of a large market town, built long ago in rough-dressed stone and intended to last forever but where not a single house remains standing following violent bombardments by heavy artillery and the ensuing general conflagration.

In the total absence of any wind the snow has settled evenly, leaving uncovered only the vertical surfaces, which now stand out against the overall scene, creating a diagrammatic pattern of pitch-black lines of greater or lesser width, with here and there odd rectangles or rhombuses, as well as pentagonal, trapezoidal, triangular, and, less frequently, curvilinear shapes, all equally blackened by the thick soot that was caused by the recent fire. In whatever direction one looks (including Henri de Corinthe and his mount), the whole countryside is thus the most perfect black and white, comparable in its clear

CATALOGUE NUMBER 3

Robbe-Grillet Cleansing Every
Object in Sight, 1981
(detail)

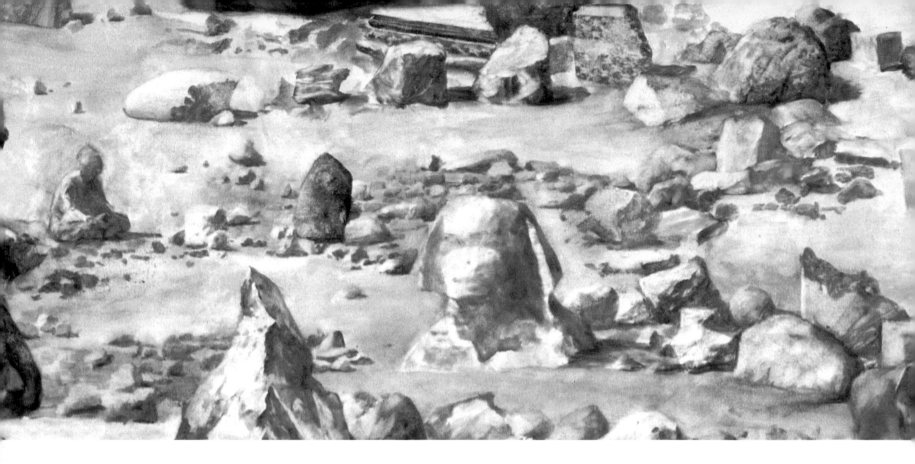

but not unduly sharp outlines to a woodcut from the last century.

 With its immaculate coat the horse walks along with so sluggish and mechanical a gait that it gives the impression of being as stiff as its master, as fixed as the whole of the ambient scenery. They might even be said to be stationary. Only the clear impressions left by the iron-shod hooves on the virgin expanse of snow mark the progressive march of a time that has become abstract. That apart, there is no other trace of movement visible, neither rider nor foot soldiers nor a stray dog nor the smallest field mouse hounded from its hole.

 In many places the dislocated fragments of houses and monuments, less veiled than highlighted by their ermine fur, reveal architectural features that are bound to elicit surprise in these rural confines of Lorraine, recognizable elements of a neo-Grecian eighteenth century that would clearly be less out of place in a large city such as Nancy: isosceles pediments with molded cornices, shafts of deeply fluted columns, stylobates, Corinthian capitals with overlapping and curving acanthus leaves. Count Henri thinks that, had he arrived the previous evening or, rather, in the middle of the previous night in the red glow of flame, he would have been taken for the Roman consul Mummius as he is depicted in a famous canvas by Tony Robert-Fleury dating from 1870. Conventional painters like conflagrations, as Ruskin was later to write.*

 But suddenly the solitary horseman, having crossed a narrower breach that had partly obscured his vision, now sees a magnificent jet-black horse bending over what seems to be human remains

Les peintres pompiers aiment l'incendie, écrivait Ruskin. The pun is difficult to translate. *Pompier* means "fireman"; *peintres pompiers* is an expression meaning conventional painters.

stretched out in the snow before him. He draws closer and soon makes out, on this young lieutenant with no apparent wound, the black uniform of the German armored divisions (he must be a liaison officer), similar in many ways to the one that Corinthe had just put on, exceptionally, this very day.

The man lies prone in the carefree posture of someone sleeping peacefully. But his eyes are wide open and staring, lifeless to all appearances. His animal, equally motionless, breathes the warm mist of its breath through its nostrils as though attempting to warm the inanimate breast, which is decorated with the broad black, white, and red ribbon of an Iron Cross of the highest rank. No white dust appears on the fine woolen cloth or on the black boots and gloves or the peaceful face of the dead man. A possible reason for this absence may be that the handsome lieu-

tenant was struck by a stray bullet when the snow had almost finished falling. The final flakes would have been sufficient to cover all trace of hooves and heels, which are, in fact, invisible all around, whereas they would have melted at once on the still warm body.

In any case, the breathing of the faithful horse could produce no more than rime, since the corpse is now frozen from head to foot, as Corinthe, having dismounted and placed one knee on the ground, can see for himself. He has even unbuttoned the stiffening military tunic and removed his own black leather glove in order to be quite sure. Beneath his fingers, which explore the cold insides of the clothes with gentleness, even with tenderness, he finds an identity card, which he would not want to miss the chance to decipher, a task to which he brings his whole attention, respect, and melancholy sadness.

The lieutenant was called Kurt von Corinth. So perhaps he was a distant relative . . . almost the same name as the novelist Kurt Corrinth (with that curious doubling of his central consonant), who had been born in 1894 (the same year as his papa) and who, an unorthodox eulogist of National Socialism, had prophesied universal communion through action, sex, and death . . . But even more than the dead man's patronymic, it is his photograph that strikes anguish into the French officer's heart.

His hand trembling with fear and impatience, he feverishly searches his own inside pocket and draws out his personal papers in order to compare the two pictures . . . There can be no doubt about it: he is looking at two identical copies, printed from a single negative, of one and the self-same photograph. Both, moreover, have exactly the same slight superficial fault, beneath the left eye, the laboratory clearly having produced them both on the same day using the same machine.

Henri de Corinthe can perfectly recall the source of the snapshot: a portrait dating from his time as instructor at the cavalry college and therefore already rather old. He had had nothing else at hand when his false documents were drawn up, documents in which he bears the code name Henri Robin, which he uses for special missions or secret travels. Falling prey to an irrational panic, he hurriedly replaces as best he can the disturbing German identity papers . . .

It is then that he discovers between his anxious fingers a rectangular piece of card, glossy on one side, which he senses at once is a family

memento . . . Count Henri's hand grows numb with fear, as though it knows in advance what the object represents. And it is with a slowness verging on paralysis that, reluctantly, he takes out a photographic print measuring 6 by 9 centimeters . . . It is a three-quarter-length portrait of Marie-Ange, apparently caught unaware by the camera, since her eyes are wide open and her lips slightly parted in a bright, unaffected smile, which confers on the snapshot a rare sensation of life.

In a gesture spontaneous and graceful, the young woman has assumed the frightened air of someone who suddenly finds not a lens but a rifle trained upon her and has raised both her hands in the air, her bare and gently curving arms feigning fearful surrender, a surrender belied by the peal of laughter about to burst forth from her lips, the sheer delight of which will explode once the shutter release has been depressed. Since she is wearing no clothes, her posture offers the viewer the youthful charm of her round, adolescent breasts, with a narrow waist a little above her delicate navel. The radiant beauty of her face must be due to the fact that she (or, rather, they) had just been making love . . . Marie-Ange was no doubt preparing to get dressed again . . . In the background, on the left-hand side, one can see hanging from a peg an officer's black tunic decorated with the Iron Cross.

But a closer study of the ambiguous expression on her face and of her attitude as a whole allows us to place a very different (and even better) interpretation upon them: it is, indeed, an army rifle trained on its attractive and incredulous victim, while another soldier, in almost the same line of vision,

takes the obscene picture of an execution. Filled with a sudden horror, Corinthe remounts his horse with so abrupt a movement that his injured knee makes him cry out in pain, while, close at hand, the sound of a single rifle shot rends the air. The French officer wonders how long this reprehensible interruption may have lasted, a break for which no allowance was made in the orders covering his mission.

Glancing some ten yards behind him, he notices to his horror that the second black horse has fallen in step behind him, as though naturally following its own master. All around, the deathly aspect of the setting seems even more disturbing to the belated cavalryman's overwrought nerves: this unknown town, built in ebony, basalt, obsidian, and Astrakhan marble, which figures on no known map, was it no more than a monumental graveyard, shelled by mistake? In the foreground, toward the lower right-hand corner of the frame, a large upright stone, carved in roman capitals, still exhibits the name of a builder of mausoleums and cenotaphs: Mark Tansey, Architect.

JUDI FREEMAN

METAPHOR AND INQUIRY IN MARK TANSEY'S "CHAIN OF SOLUTIONS"

What does it mean to make pictures about pictures in 1993? The question is posed not simply to raise the by-now familiar issue of the role of representational (or, as Mark Tansey describes it, pictorialist) painting in the postmodern era. These days it is well known that a figurative tradition in painting flourished throughout the twentieth century, coexisting with abstraction. The evolutionary interpretation of art as becoming increasingly reductive until it reached a pure state in the 1960s is now considered in virtually every critical camp as another of those "modernist myths." The art of the 1970s is seen today as the product of a pluralist decade, this pluralism continuing through the early 1990s.

CATALOGUE NUMBER 20

Constructing the Grand Canyon,
1990
(detail)

When Mark Tansey elected to make pictures about pictures, his was a strategy of confronting the predilection of critics of the late 1970s for minimalism and other forms of abstraction. The very existence of a critical imbalance had emboldened artists to strike out in opposing directions.[1] That Tansey was not without allies among New York-based artists was evident from a variety of artists shown beginning with the *Pictures* exhibition organized by Douglas Crimp at Artists' Space, New York, in 1977 and continuing through the *Fictions* exhibition organized by Douglas Blau at Kent Fine Art and Curt Marcus Gallery ten years later.[2] During that period Troy Brauntuch and Mark Innerst both challenged the conventions of pic-

torial representation through their blurred renderings of interior or exterior settings, aided in Brauntuch's case by borrowing historical imagery. So too had Michael Zwack in his out-of-focus, richly symbolic landscapes. Matt Mullican had made signs and symbols the elements from which his hieroglyphic tableaux were constructed. (The categories from which he develops his imagery—the "subjective," "language," "world framed," "the elemental"—are remarkably similar to the critical interrogatives that Tansey uses.) John Bowman, with whom Tansey was closely associated in the mid-1980s, was using erasure as the primary method for making his conceptual Old Master-inspired paintings. David Salle, whose choice of imagery is far removed from Tansey's and these other artists', nevertheless expressed the same sentiment in 1979 on the occasion of the Whitney's *New Imagist Painting* exhibition: "One senses imagery is creeping into the arena of New York painting and sculpture at a time when the formalist hegemony, with its concerns for 'pure' perception, is breaking up. People seem to want to look at pictures of things again."[3]

Tansey appeared to articulate the views of many of these artists when he later reflected:

In the late 1970s, what was particularly attractive about pictorial representation was that one faced an opening and extending realm of content rather than dematerialization, endgames, and prolonged swan songs. Difficulties lay in the long established and increasingly critical isolation of subject matter from art practice. Critical discourse and art education had restricted the notion of content to two

pockets coalescing around formal and conceptual poles. To speak about subject matter in a picture simply was not done.

My feeling was that there was no longer any justification for these restrictions. Pictures should be able to function across the fullest range of content. The conceptual should be able to mingle with the formal and subject matter should enjoy intimate relations with both.[4]

Tansey identifies his distinctive role "as opening up content" and perceives the current environment for artists as making that permissible.[5]

If any painting serves as a visual manifesto in support of the artist's view, *A Short History of Modernist Painting*, 1979–80 (CAT. NO. 1), is the one. The painting transforms the arena of elevated art discourse into that of popular culture. The first eight panels make reference to the metaphor, expounded by formalist critics, of the canvas as an illusionistic window. Reading left to right along the top of the canvas: a couple gazes through a Washington Monument porthole at a dramatically foreshortened view of the Capitol and Mall; one housewife transforms a painted wall into an illusionistic forest by applying wallpaper, while another cleans a floor-to-ceiling glass door that lets a real forest penetrate her living room; a man splatters a windowpane with a hose; a woman, by lifting a shade, permits three men to peer into a room; another woman in lingerie pulls open draperies revealing a virtually closed set of venetian blinds; one man leaps through a pane of glass, while another makes a more conventional exit by swinging a car door aside. The

CATALOGUE NUMBER I

A Short History of Modernist Painting, 1979–80
Oil on canvas
72 x 72 ins. (182.9 x 182.9 cm)
Eli Broad Family Foundation,
Santa Monica

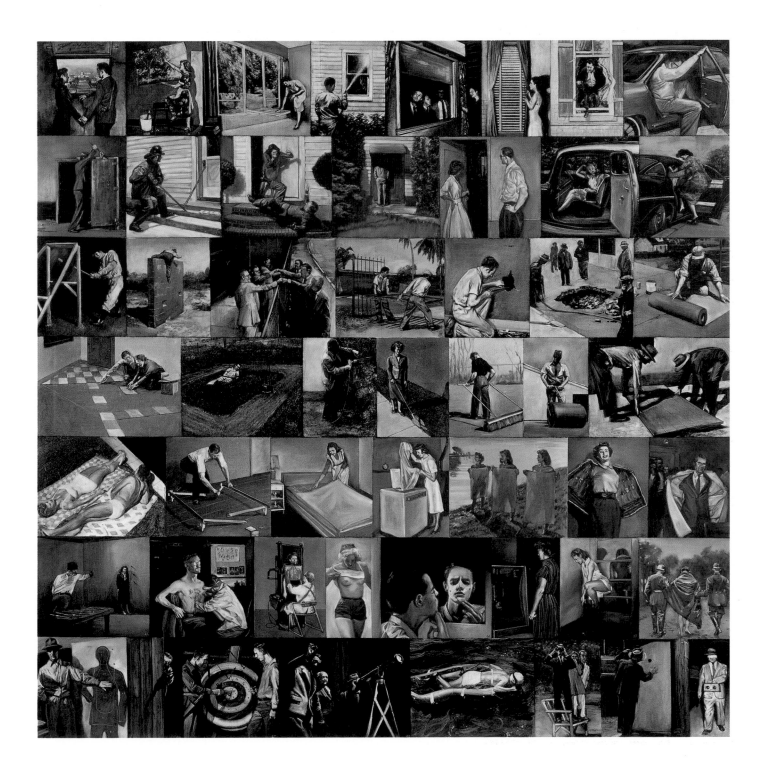

images allegorize modernism's unfolding. From illusionistic Renaissance space to the elimination of illusionism in color field painting; from the blanketing of the canvas with paint randomly applied to the breaking of the frame and painted field; from the viewer's ability to step through the window to the artist's insistence on keeping the viewer at bay—Tansey's images, crafty extrapolations from such magazines as *Popular Mechanics* and *National Geographic*, allude generically to a particular critical account of modern painting.

Designating this painting his "Stations of the Picture Plane," Tansey links it with Barnett Newman's multipaneled *Stations of the Cross*.[6] Where the elder artist's paintings may be seen retrospectively as the culmination of one oeuvre, Tansey identifies it as the starting point of his own.

"Every important work of art can be regarded both as a historical event and as a hard-won solution to some problem," wrote art historian George Kubler.

It is irrelevant now whether the event was original or conventional, accidental or willed, awkward or skillful. The important clue is that any solution points to the existence of some problem to which there have been other solutions, and that other solutions to this same problem will most likely be invented to follow the one now in view. As the solutions accumulate, the problem alters. The chain of solutions nevertheless discloses the problem.[7]

Tansey's work does indeed constitute a kind of chain, a plaited chain or braid, each picture a portion of a metaphorical strand, the strands themselves relatively distinguishable as associated with at least one of three types.

The first of these is represented by the quest: for meaning, for comprehension, for truth. Figures in Tansey's paintings assume poses suggestive of hunting, peering, searching, surveying, scavenging.

The second strand is conflict or confrontation at a crossroad. People clash, sometimes physically, sometimes psychologically (conveyed by facial expression, body language, posture, or attire). Conversely they may appear to bridge a rift.

The third group of images is drawn from the art world, to which Tansey has belonged for more than two decades. He considers the traditions of art history and their critical assessment suitable for investigation. For him the meaning of the creation of art as well as the contest between an artist's inclinations and the perceived constraints of critical opinion are subjects of considerable interest, and he has returned to them at key moments throughout his career.

Tansey's paintings on first reading are deceptively legible; they are landscapes, interiors, shallow spaces. Each is painted a monochromatic cyan, cadmium red, sepia, or gray, so that otherwise "impossible encounters and reconciliations can take place plausibly."[8] Figures are depicted in a photographically naturalistic, yet passé style. Movement, as in a photograph, is arrested, yet as with photography, with its presumed basis in something "real," the viewer accepts the veracity of the scene, drawing upon its constituent elements for a clue to its content.

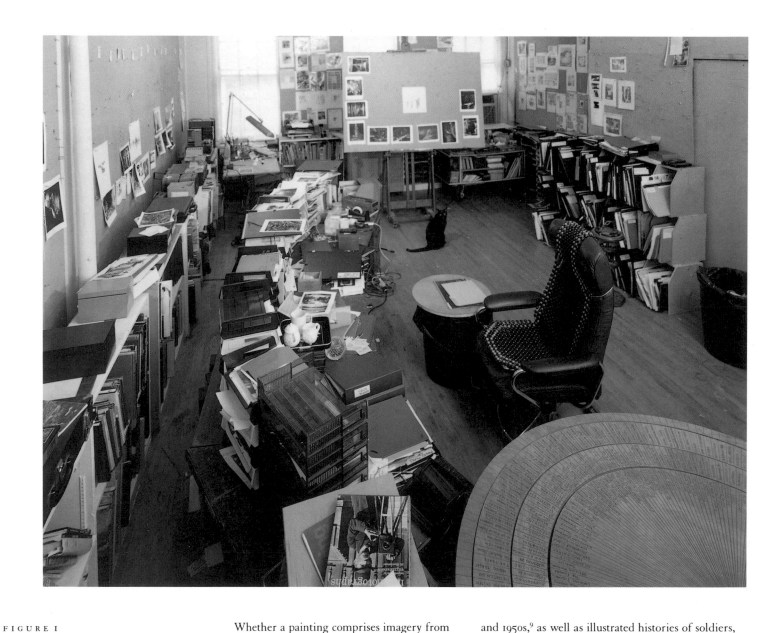

FIGURE 1

Mark Tansey's studio/archive,
Warren Street, New York,
1992.

Whether a painting comprises imagery from one, two, or all three thematic groupings, the principal clues are in the figures Tansey deploys from a daunting archive of clippings, initiated in 1977–78 while a graduate student at Hunter College. His sources are magazines, many dating from the 1940s and 1950s,[9] as well as illustrated histories of soldiers, armaments, and costumes. Images are classified and preserved in binders in his studio (fig. 1). In one binder alone, now a basic reference book, are amassed eighty-seven album pages of poses, which he character-

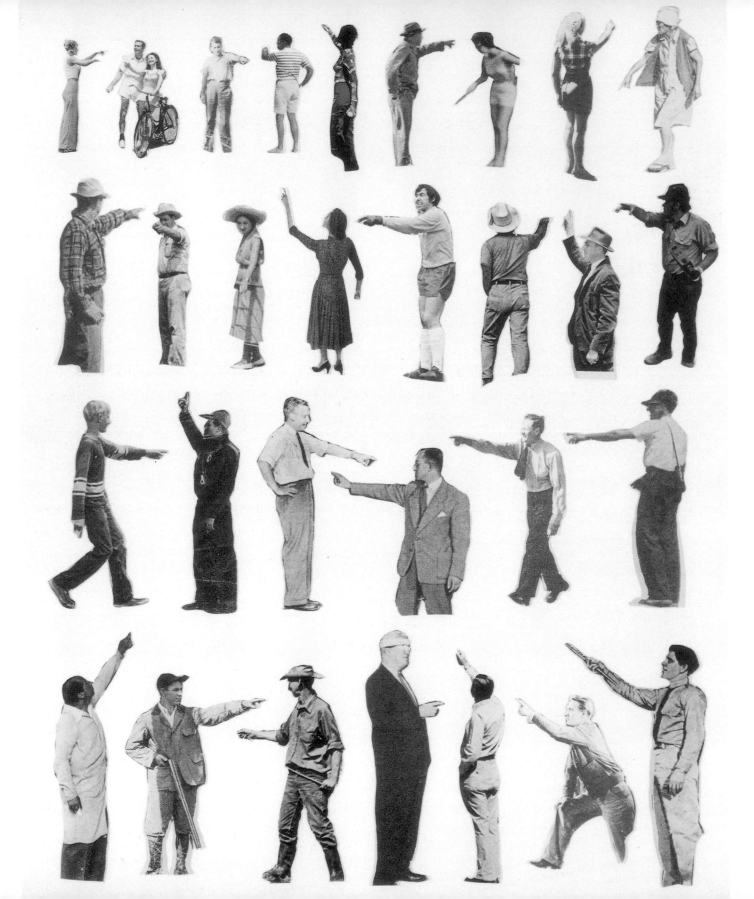

izes as "the stock postures that our culture serves up."[10] A sampling is indicative of his thinking and method of organization: men and women looking contemplatively downward, hands on hips, in pockets, crossed, to the side; men and women gesturing upward, outward, pointing, arguing (fig. 2); seated men with hands folded, clasped, or clenched; men and women peering with naked eye, with eyes shielded, through binoculars; men and women kneeling, bending; women walking. Like ranks of toy soldiers, figures are deployed in rows, grouped by size, the smallest at the top, the largest at the bottom. Tansey's goal has been to assemble a lexicon of poses, but if a required pose is missing, he has not hesitated to create it photographically—often with himself or wife, Jean, as models (as seen in the painting *The Key*, 1984)— and add it to his inventory.

Tansey transforms photographic into painted images that are within the conventions of representational/pictorialist painting. Allegories told through photographically derived imagery are more accessible than others. The ineffable familiarity of the figures promotes confidence in the images' veracity. Their poses provide clues to the identity of the dramatis personae and to the nature of their relationships. They encourage the viewer to begin by interpreting the painted scene on some basic level and then to progress to more recondite meanings.

Tansey believes that "little is known about how to make pictures mean."[11] To fully decode a Tansey image, a viewer may have to replicate the artist's working process. The metaphorical search

can be interpreted, for example, as an analogy for Tansey's *research*.

For every picture the artist conceives a panoply of questions, which in the case of his most recent pictures are laid out in rows along the perimeter of a rectangle (fig. 3). These questions are concrete manifestations of what Tansey describes as "trajectories," various paths underlying a picture which provide its conceptual, rather than its visual, framework. The questions, which resonate with the journalistic litany—who? what? where? when? and why?— establish the parameters of his subject matter and are designed to classify and situate the elements of his pictures. In effect, they clarify the trajectories.

Initially Tansey considers the picture type, what he describes as the "dynamic," or the forces governing the activity depicted as well as the picture's creation. He studies the relationship of language to the understanding of details as well as to the picture as a whole. He evaluates the pictorial styles and procedures involved in the making of his own pictures as well as those practiced by artists throughout history.

Tansey then scrutinizes all aspects of a painting as it emerges. Using his question grids, he examines its underlying meaning. What is the theme? What is the title? What is the problem? What is the new metaphor?

The setting is considered. Where is this? What world is it? What laws or forces prevail? What is being transformed? What problems does the context produce?

FIGURE 2

Reference Notebook, begun 1977
Pasted paper collage
11 x 8½ ins. (27.9 x 21.6 cm)
Collection of the artist,
New York

The figures depicted are inspected to make them more precise. Who is present? What are they doing? How do they function spatially? What conditions affect their activities? How do they control the narrative trajectories? Are they in crisis? What issues or forces do they confront? Do they confront them with the appropriate tools?

Tansey's gridded, gameboard paintings, such as *A Short History of Modernist Painting* and *Seven Deadly Sins*, are filled with disparate images, which, when juxtaposed, suggest possibilities for "compiling 'icons in crisis' or conceptual hybrids as subjects— subject matter."[12] They anticipate the principal vehicle by which he has formulated this inquiry since 1988: his wheels. The wheels consisted initially of three concentric paper disks laid atop one another and fastened at the center. On its rings Tansey arranged phrases, which, when combined, created generalized but ambiguous statements applicable to a variety of situations: "vanguard rediscovering decentered subject," for example, or "empty subject stabilizing closet formalist." Among the 154 nouns on its innermost ring, for instance, *Color Wheel*, 1989 (fig. 4), includes *collusionists, destabilizer, disinformant, historians, iconoclasts, post humanists, rear guard*, and *vanguard*. The second ring consists entirely of participles: *abolishing, diagnosing, embracing, excavating, mastering, probing, recoding, reinventing, renovating*, and *reversing*. Along the outermost ring are nouns and phrases that become objects of the participles as the rings are spun: *head of the mergers department, ideological stunt man, latter-day Cartesians, potential primitive, preppy ideologue, prohibitors, veteran of foreign texts*. Many of these terms have

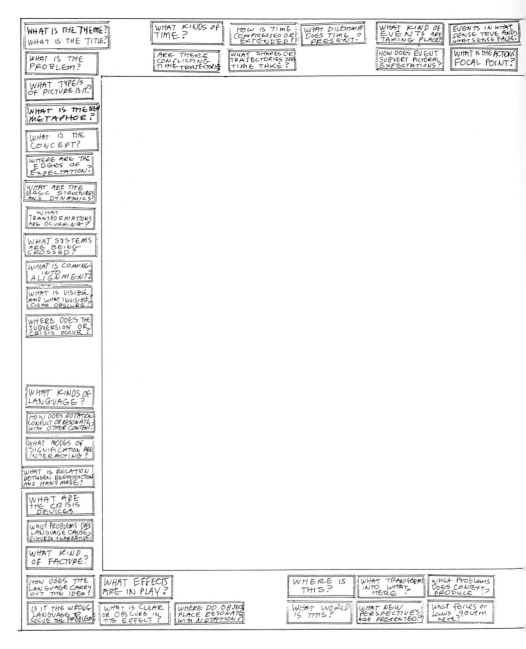

FIGURE 3

Untitled, 1986

Ink on paper

11 x 17 ins. (27.9 x 43.2 cm)

Collection of the artist,

New York

Figure 4 — boxes reading:

WHAT SHAPES DOES NARRATIVE TAKE? | WHAT SPATIAL SCALES DO EVENTS TAKE PLACE IN? | WHO IS IT? | WHAT ARE THEY DOING? | WHAT SYSTEMS ARE THEY MEDIATING? | HOW DOES FIGURE SHAPE NARRATIVE TRAJECTORY

WHAT IS THE SPATIAL-TEMPORAL SHAPE OF EVENT? | WHAT EVENTS ARE HAPPENING SIMULTANEOUSLY | TITLE FIGURE IS A CROSSROADS OF WHAT TRAJECTORIES | WHAT FORCES OR RULES GOVERN THEM | WHAT PATTERNS OR CONTINUITIES ARE THEY PART OF?

WHAT IDEOLOGICAL MODE IS FIGURE ENACTING?

WHAT ARE FIGURES DYNAMIC FUNCTIONS?

WHAT KIND OF TIME DOES THE FIGURE INDICATE?

FIGURES ARE IN WHAT SORT OF CRISIS?

HOW DO THEY ENHANCE OR RESOLVE THE PROBLEM?

FIGURES OFFER WHAT CONTRASTING MODES OF SIGNIFICATION?

HOW DOES THE FIGURE FUNCTION SPATIALLY?

ARE THERE FRAGMENT NARRATIVES?

IS THERE A FIGURATIVE EQUATION?

WHAT KINDS OF GESTURE GRAMMARS?

ARE THEIR ACTIONS APPROPRIATE? TO WHAT?

HOW IS SEXUALITY APPARENT?

THEIR CLOTHES IMPLY WHAT KINDS OF FUNCTION?

WHAT IS THE FIGURES RELATION TO FORMAL PICTORIAL SPACE

TO WHAT DEGREE ARE THEY INVISIBLE?

WHAT FORCES ACT UPON THE FIGURES?

WHAT IS THEIR RELATION TO NATURE?

WHAT ARE THE FIGURES' SOURCES?

WHAT IS IT? | ARE THEY USING THE WRONG TOOLS TO SOLVE PROBLEM? | DO OBJECTS NARRATE? | WHAT TRANSITIONS OR TRANSFORMATIONS ARE OBJECTS IN? | DO FIGURES FUNCTION AS SIGNS-OBJECTS? | HOW DOES FIGURE RESONATE OR CONFLICT WITH THE LANGUAGE?

WHAT ARE THE OBJECTS MEDIATING? | WHAT TIME-SPACE TRAJECTORIES ARE OBJECTS FUNCTIONING IN? | WHAT ARE THE SUBVERSIVE ELEMENTS? | WHAT TOOLS DOES FIGURE USE? | WHO IDENTIFIES WITH THE FIGURE?

TANSEY

FIGURE 4

Color Wheel, 1989

Ink on paper

17 x 17 ins. (43.2 x 43.2 cm)

Collection of the artist

(overleaf)

CATALOGUE NUMBER 22

Mark Tansey in collaboration

with Fritz Buehner

Wheel, 1990

Plywood and wood veneer

38 x 48 x 48 ins. (96.5 x 121.9 x

121.9 cm)

Howard E. Rachofsky

(page 23)

their origins in critical theory;[13] Tansey has a considerable collection of books on such theory, which he has underscored assiduously.

The most elaborate wheel, 1990 (CAT. NO. 22), a collaborative work with Fritz Buehner, refines the process. Made of wood and erected much like a lazy Susan mounted within a table thirty-eight inches high, the wheel facilitates casual turning. Its organizational structure resembles earlier versions in its subject-participle-object configuration, but the increased number of entries on each ring—180— results in 5,832,000 possible combinations (compared with the 157,464 possible combinations on the older paper wheels). By exhibiting the wheel and inviting viewers to spin it, the artist in effect authorizes them to explore the range of ideas available within the vocabulary he provides. "The wheel also has the double function," he explains, "as art object and game for inventing new metaphors and extending content."[14] *Game* suggests that Tansey welcomes the chance combinations that result. Nevertheless he selects carefully from among the combinations the most stimulating trajectories to bring into dialogue with the developing image.

Tansey routinely spins his wheels, notes the combinations, and charts the results of selected spins, classifying them under headings of oppositions, problems, motifs, meta-themes, modes of transformation, and language motifs (devices) (fig. 5). These lists, kept in the form of grids with space available for additions, provide a source of ideas for application to works in progress and newer compositions. While each item is independent of its neighbors, it is made more dynamic

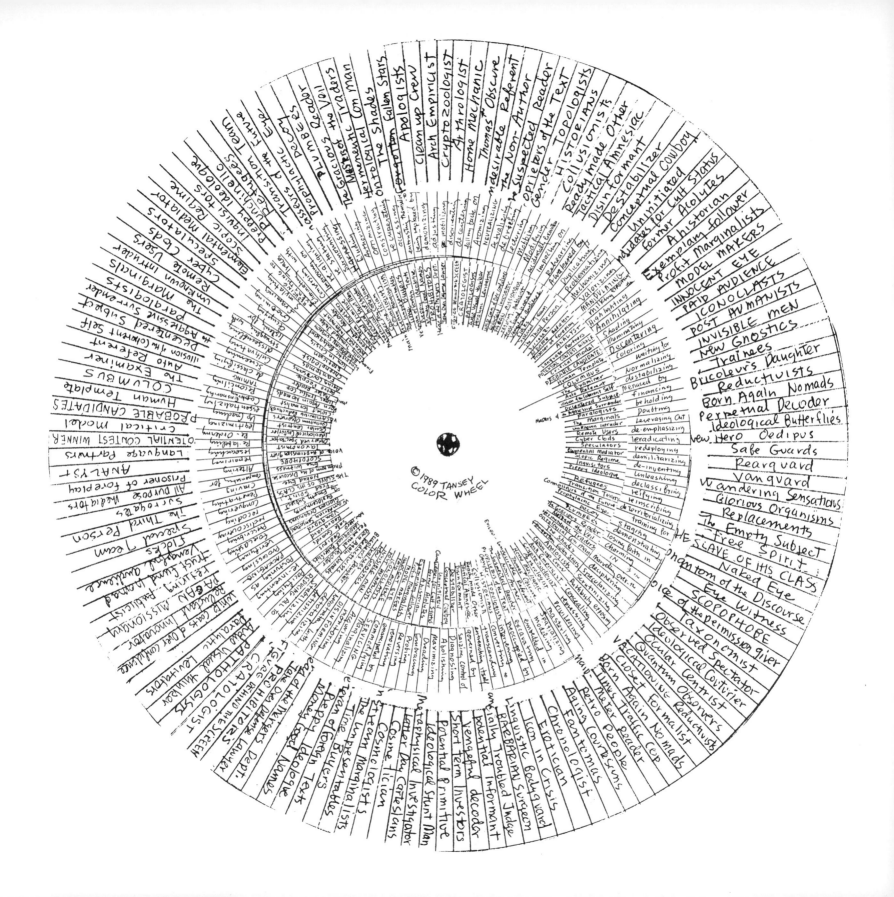

© 1989 TANSEY COLOR WHEEL

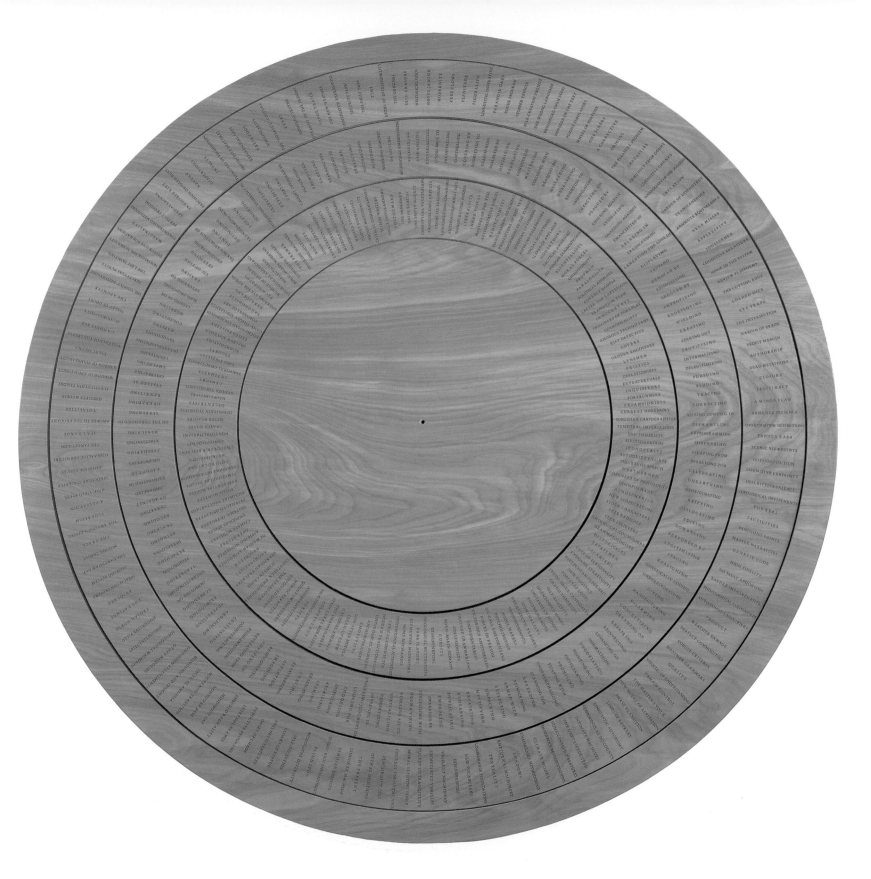

OPPOSITIONS

ACCIDENTAL / DELIBERATE	SCIENTIFIC / SEXUAL	ACTIVE / PASSIVE
PLAUSIBLE / IMPLAUSIBLE	SEMIOLOGICAL / SEXUAL	WEAK / STRONG
CONSCIOUS / UNCONSCIOUS	VISIBLE / INVISIBLE	ERECT / FLACCID
ART HISTORIC / HISTORIC	GRAVITY / LEVITATION	SUBJECTIVE / OBJECTIVE
EXPECTED / EXPECTED	RIGHT SIDE UP / UPSIDE DOWN	WET / DRY
CONTROL CHAOTIC / RANDOM	BACK / FORTH	RAW / COOKED
INDEXICAL SYMBOLIC / REPRESENT.	SURFACE / DEPTH	FILLING / EMPTYING
CLEAR / OBSCURED	DARK / LIGHT	
MOBILE / IMMOBILE	MILITARY / SOCIAL	
SCIENTIFIC / MYTHIC	QUANTUM / RELATIVITY	
FICTIONAL / NONFICTION	MORAL / IMMORAL	
TRUE / FALSE	HIDING / EXPOSING	
MECHANICAL / SEXUAL	IDENTITY / ESSENCE	
IDEOLOGICAL / BIOLOGICAL	CAUSE / EFFECT	
MAGIC / PHILOSOPHIC	ARTIFICIAL / NATURAL	

MODES OF TRANSFORMATION

ACTUAL / SIMULATION	DAY – NIGHT
TEST / REAL	MEDIUM / MESSAGE
DRAMATIZING / REAL	SIGNIFIER / SIGNIFIED
EXTENDING / CONTRACTING	LINEAR / NON-LINEAR
FORWARD / REVERSE	SYSTEMATIC / ERRATIC
REDUCTIVE / PRODUCTIVE	CERTAINTY / DOUBT
CONSTRUCTIVE / DECONSTRUCTIVE	PRESCRIBED / PROHIBITED
MARGINAL / MAINSTREAM	ORIGINAL / COPY
LABEL / SUBSTANCE	KNOWN / UNKNOWN
SMALL-LARGE / SCALE	SINGULAR / MULTIPLE
TIME FAST-SLOW	CONVENTIONAL / UNIQUE
ALIGNED / ASKEW	HOT / COLD
CENTERED / DECENTERED	ASLEEP / AWAKE
RIFT / RESONANCE	COMPLEX / SIMPLE
VICE / VIRTUE	ATTRACTION / REPULSION
WATCHING / WATCHED	ROUGH / SOFT
SEEING / BEING SEEN	TRANQUIL / STORMY
Balance / imbalance	PRODUCTION / CONSUMPTION
FRAMED / UNFRAMED	LINKING / BREAKING
POSITIVE / NEGATIVE	LOUD / QUIET

PROBLEMS

CORNERING THE REAL	SLOW MOTION TIMING SHED STRETCHES	THE NOISE PROBLEM	IMPOSSIBLE MEETING	SELF DECEPTION	EMPTY SUBJECT	SHIFTED REFLECTIONS
STOPPING TIME COMMODIFYING THE PRESENT	SEMIOTIC LEVITATION	LANGUAGE FOLLIES	POSING NEGATIVE IMAGE SHIFT	FRAMING PROBLEMS	WRONG LANGUAGE TO SOLVE PROBLEM	OBJECT – PLAN DISCREPANCIES
LOST IN LANGUAGE	DENIAL OF GRAVITY BY TEXT	FALSE PROOF	UP DOWN CREDIBILITY PROBLEMS	VIEWPOINT PROBLEMS	INVISIBLE RIFT	HIDDEN IMAGE
SEX – SCIENCE PROBLEMS	REVERSING TIME PROBLEMS	LOSS OF HISTORY	CULTURAL IRRECONCILIATION	CHINESE BUTTERFLY PROBLEM	ALIGNMENT	VERIFYING the UNVERIFIABLE
GENDER PROBLEMS	SHADOW PROBLEMS	BEING LOST IN ONE WITH CREATURE	PRESTIGE PROBLEMS	MEASUREMENT METER READING PROBLEMS	STILL LIFE PROBLEMS	Capturing the present as COMMODITY
COLLABORATION / COLLUSION	JUDGEMENT PROBLEMS	NATURE RULED BY REPRESENTATION	EMBODIMENT DISEMBODIMENT	TEST PROBLEMS	SCALE SHIFTING	NATURE IMPROVEMENT
GENDER TOPOLOGY PROBLEMS	ABSENCE OF VERIFICATION	RECONCILING MULTI-DIMENSIONAL EXPERIENCE				

META-THEMES

PAPER SCISSORS STONE	Le FAUX PAS	Valley of Doubt	Correct Methodology	FOCAL PULSE	THE SOURCE (ORIGINS)	measuring the unmeasurable
STOPPING TIME	BLIND SPOT	Trimming the FAULT TREE	PUSH-PULL	Review Platforms	Reconciliation	Nature Improvement
THE CONVERSATION						
Judgment of Paris						
THE FLAW						
NOTHING LEFT TO CHANCE						
CAPTURING THE REAL						
CARTESIAN GAP						
THE KEY						
SOLAR SYSTEM						
Lingua Ex Machina						
Border Dispute						
NON-MEDIATION						
STRANGE EQUATION	THE BLINK	ILLUMINATION (SHOOTS)	Water Hole	Triumph over Mastery	Take One	Awakening
GAP PROBING	POCKET OF TRANQUILITY	ESCAPE FROM HISTORY	UTOPIC VEHICLE	CONQUERING THE WEATHER	GARDEN OF DISCONTENT	IMPOSSIBLE TRANSFORMATION
Search for Autonomy	Levitation Attempts	BLINDNESS + INSIGHT	THE PRESENTATION	Looking at Polaroids	Weak Point of the Arch	Arts of the VEIL

LANGUAGE MOTIFS – (DEVICES

REVERSALS COLLATING REFLECTIONS	MACGUFFIN – PRESENTING THE UNPRESENTABLE	PUSHING + PULLING THE SPATIO-TEMPORAL CULTURAL BOX	GAP + DISCREPANCY ANALYSIS THE INTERSECTION	OVERLAYING IMPACTS	SCALE SHIFT AS MEANING SHIFT DETAIL FOCUS	INVISIBLE RIFTS
TENUOUS JUXTAPOSITIONS VIGNETTE BUTTING	WRONG NOTATION TO SOLVE PROBLEM	EXTENDING + CONTRACTING TIME + SPACE	EXPLOITING THE MARGINS	VEILING + CLUMPING OVERLAYS	LITERAL-TEXTUAL-SYMBOLIC CROSSING OUT	LEVITATING BY ANY RULES
BENDING STRETCHING FOLDING IMAGE	TAKING APART AND RECONSTRUCTING	REFRAMING BY STEPPING BACK DECONTEXTUALIZING	REVERSING SPATIO-TEMPORAL ORIGINAL=COPY SIGNIFIED=SIGNIFIER	THE LOOSE SHADOW – CAST ANYWHERE	ALIGNING MIS-ALIGNING	ANYTHING CAN BE DONE TO AN OBJECT

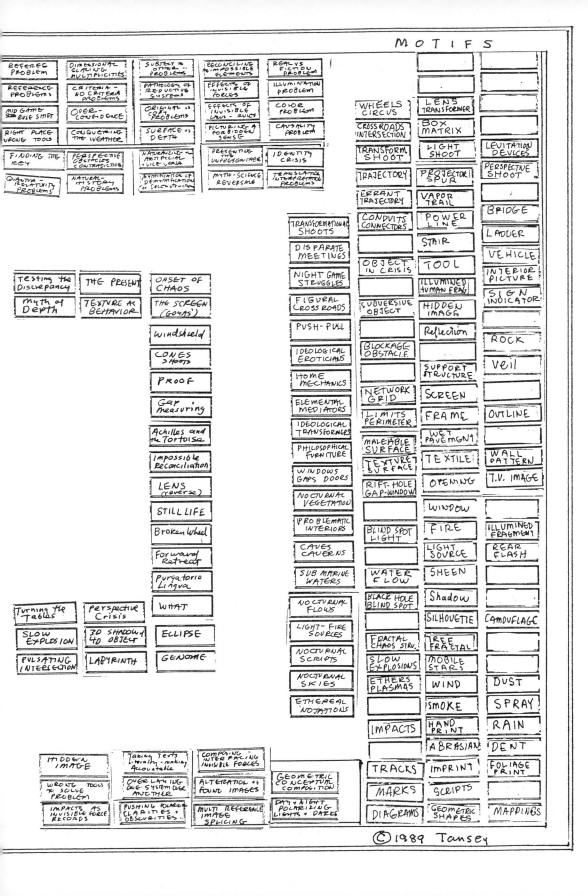

MOTIFS

© 1989 Tansey

METAPHOR AND INQUIRY

FIGURE 5

Untitled, 1989

Ink on paper, 11 x 17 ins. (27.9 x 43.2 cm)

Collection of the artist, New York

by its proximity to equally provocative concepts. "Measuring the unmeasurable" adjoins "testing the discrepancy," which in turn abuts "the present." Were these to form the basis of a yet-unrealized composition, the range of imagery would be limitless.

Clearly the words and phrases comprising Tansey's wheels and charts exceed elementary reading levels, but Tansey has chosen them deliberately because their complexity mirrors the contemporary philosophical, ideological, and aesthetic weightiness of the general philosophical issues he addresses. The same issues may be perceived, however, on more fundamental levels. This is why the recurrence of certain themes in Tansey's work has such resonance for viewers unfamiliar with the extensive preparation and conceptualization underlying each picture.

It would be wrong to conclude, however, that Tansey is simply a representational painter, electing to make figurative pictures at the start of his career in the face of the dominance of abstract painting; that he makes paintings that fall precisely into one of three thematic categories; and that he creates using an idiosyncratic and compulsive method that he applies consistently to each work. None of these assertions is true. As a result, the content of each picture demands its own act of unearthing. "Underneath each picture there is always another picture," Douglas Crimp observed in a seminal 1977 essay.[15] Perhaps he stated the obvious. In Tansey's case each picture conceals two or three or more. Images stand for images that represent an altogether different set of ideas. Tansey's

paintings are in this sense visual allegories or sometimes pictorial texts.[16]

As the critic Craig Owens noted,

Allegorical imagery is appropriated imagery; the allegorist does not invent images but confiscates them. He lays claim to the culturally significant, poses as its interpreter. And in his hands the image becomes something other (ALLOS = other + AGOREUEI = to speak). He does not restore an original meaning that may have been lost or obscured; allegory is not hermeneutics. Rather, he adds another meaning to the image.[17]

Tansey's images are destined to be read and reread, although the artist does not intend the activity to overdetermine the process of looking at pictures. As he observed in 1986, "A painted picture is a vehicle. You can sit in your driveway and take it apart or you can get in it and go somewhere."[18] In this respect he is much like René Magritte; he wants his imagery to be seen as both accessible and open-ended.[19]

Tansey is an avid reader of structuralist and deconstructionist texts, which has helped to stimulate his investigations and confirm some of his thinking. Roland Barthes's defines the artist's strategy precisely:

It is no longer the myths which need to be unmasked . . . it is the sign itself which must be shaken; the problem is not to reveal the (latent) meaning of an utterance, of a trait, of a narrative, but to fissure the very representation of meaning, is not to change or purify the symbols, but to challenge the symbolic itself.[20]

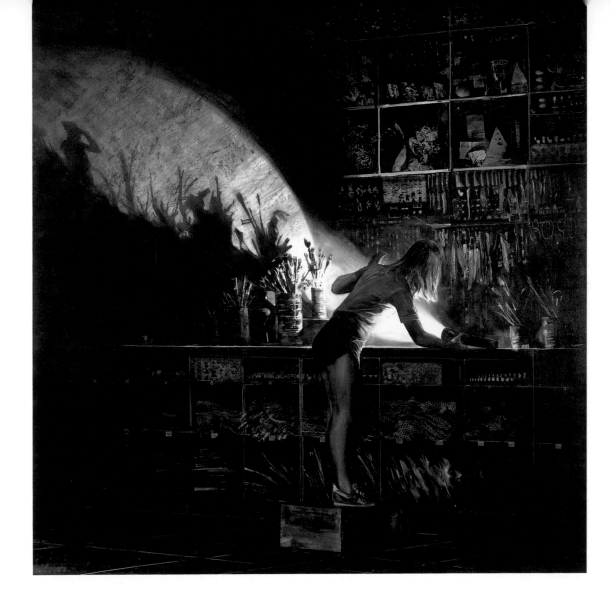

CATALOGUE NUMBER 14

The Bricoleur's Daughter, 1987

Oil on canvas

68 x 67 ins. (172.7 x 170.2 cm)

Emily Fisher Landau,

New York

Each link in Tansey's "chain of solutions" aids in decoding his pictures. First among his metaphors are images of searching. Humankind's confrontation with the unknown, the mysterious, or the awe inspiring serves as Tansey's metaphor for the eternal quest for knowledge. The quest underlies every aspect of Tansey's picture making; it explains his elaborate method of working. Tansey describes the "metaphor for the function of painted pictures, as I'm beginning to see it, as *inquiry*. The picture as question. Picture making as questioning."[21]

The Bricoleur's Daughter, 1987 (CAT. NO. 14), presents us with a young woman standing on a wooden box, aiming a light past brushes and other implements onto the wall of a cavernous workshop. We cannot see her face but conclude from her posture that she is peering into a darkened corner. A bricoleur, Tansey explains, is a "French handyman who has a limited set of tools that he uses to solve any problem."[22] Is the bricoleur's daughter trying to suss out her father's arcanum?

Freeman

CATALOGUE NUMBER 7

The Key, 1984

Oil on canvas

60 x 48 ins. (152.4 x 121.9 cm)

Gretchen and John Berggruen,

San Francisco

For Tansey the questing individual is almost always a figure with back turned to the viewer. Sheets in Tansey's binders show rows of silhouetted figures seen similarly from behind. In *The Key*, 1984 (CAT. NO. 7), a woman (based on a photograph of Jean Tansey) stands impatiently watching a man (based on a photographic self-portrait) search for the key to a pair of towering gates (in fact, Lorenzo Ghiberti's fifteenth-century *Gates of Paradise*). Will the key, once found, unlock their meaning?

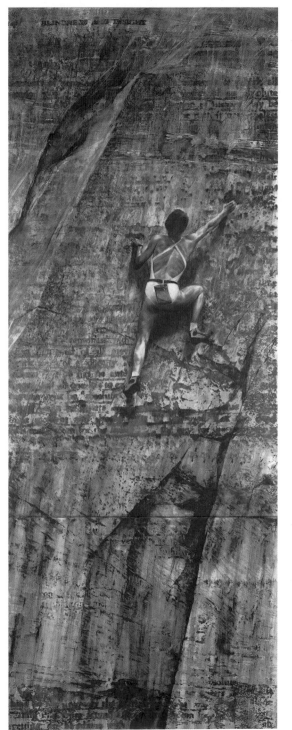

CATALOGUE NUMBER 19

Close Reading, 1990

Oil on canvas

121½ x 46 ins.

(308.6 x 116.8 cm)

Collection of Modern Art
Museum of Fort Worth,
museum purchase, Sid W.
Richardson Foundation
Endowment Fund

CATALOGUE NUMBER 20

Constructing the Grand Canyon,
1990

Oil on canvas

85 x 126½ ins.

(215.9 x 321.3 cm)

Collection of Walker Art Cen-
ter, Minneapolis, gift of Penny
and Mike Winton, 1990

(overleaf)

In *Close Reading*, 1990 (CAT. NO. 19), an athlete scales a rock built from text. She attempts to read it, but the viewer senses that she is struggling with her task. Is she too close? Is the text indecipherable? Since we can no more decipher the text than she, we sympathize, as we did with the bricoleur's daughter, with the protagonist's dilemma.

The notion of "close reading" originates in the writings of Paul de Man, the Belgian deconstructionist philosopher. In his *Blindness and Insight* de Man asserts that critics who engage in close reading are blind to their own assumptions and consequently misinterpret what they read: "Literary texts are themselves critical but blinded, and the critical reading of the critics tries to deconstruct the blindness."[23] This is a concept central to deconstruction, an effort pioneered by literary critics such as Jacques Derrida and de Man to analyze written discourse and expose the imprecision of words as representations (or "signs") of the tangible and intangible. The athlete in *Close Reading* appears oblivious to the *content* of the somewhat obscured text. Her effort, evidenced by her taut muscles and sweaty limbs, suggests that her quest for meaning is itself more meaningful than the subject of her text.

Tansey's paintings, especially those created after 1987, have incorporated text. Caught up in the fascination of artists with critical writing and particularly with the critique of representation, Tansey has immersed himself in reading. His library is rich in theoretical literature,[24] and he has participated in discussion groups of artists, writers, and historians.[25] But to what degree has Tansey engrossed himself in a

theoretical morass? What has he extracted from it? To what extent has he fused general theoretical concepts with specific artistic issues? The very presence of text in his recent paintings certainly signals the integration of theoretical speculation into the content of his images. As he notes,

Included in the art discourse of the early 1980s was a critique of representation that, in part, proposed a general opposition between representational painting and postmodern textuality. The critique had it that the mode of representation was uncritical, complicitous with conservative institutions, retrogressive, and based on linear historicist continuities. Its meanings were taken to be single coded, single messaged, and totalizing. Originality and authenticity were merely seen as the bases for the artist's assumption of cultural authority.

In contrast, textuality supplanted the artist with the rhetorician and grammatologist, whose task it was to problematize and destabilize the act of reference, to display the gap or discrepancies between the representation and its subject. . . .

As the critique progressed, a few problems arose. It became apparent that texts are representations. Furthermore, representations are texts—inasmuch as they are the objects of textual analysis. Questions followed. How could a text be critical if the meaning of a text is indeterminate? What made anyone think that the painted representations were limited to one meaning? Or only to the past?

It seemed to me that this rather strained dichotomy could be questioned pictorially by putting text into play literally and figuratively. By beginning with the printed page as motif: on one side the text and on the other side the image. The underlying questions were: How does representation transform into text? Where does the pictorial rhetoric begin and where does the rhetorical text end?[26]

It is indeed difficult to distinguish between the textual and the pictorial in Tansey's recent work. Just as he queries the distinction, so too does the viewer. The text in Tansey's paintings requires the viewer to attempt at least decipherment. Yet Tansey's interest in deconstruction—both in his pronouncements and in the "casting" of his characters, including many well-known literary critics—undercuts the ease with which the paintings can be decoded. The most notorious members of the Yale school of deconstruction—Harold Bloom, de Man, and Geoffrey Hartman—are central among the figures in the middle ground of Tansey's *Constructing the Grand Canyon*, 1990 (CAT. NO. 20); the figure of Jacques Derrida, who provided the direct link between the American and French schools of deconstructionism, is centrally placed alongside de Man. The debate between de Man and Derrida, two critics who, in fact, are more alike than different in their writings, is the subject of *Derrida Queries de Man*, 1990. The very title *Under Erasure*, 1990, is virtually identical to what can be characterized as the deconstructionist motto: "*sous rature*" (under erasure) is perhaps Derrida's most familiar coinage, often employed to describe the deconstructionist method of printing texts and striking through them.[27] Many of Tansey's painted texts are themselves "under erasure";[28] Tansey takes pages of published text, which he has underscored, crumples them, and then silkscreens them onto his can-

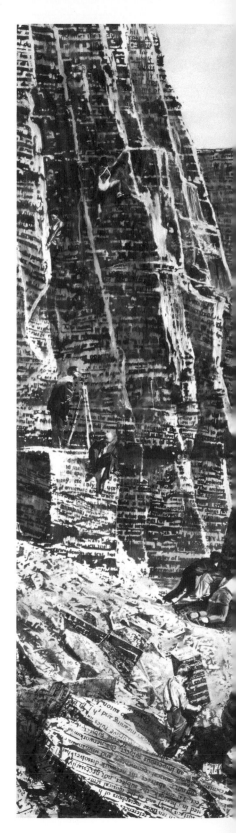

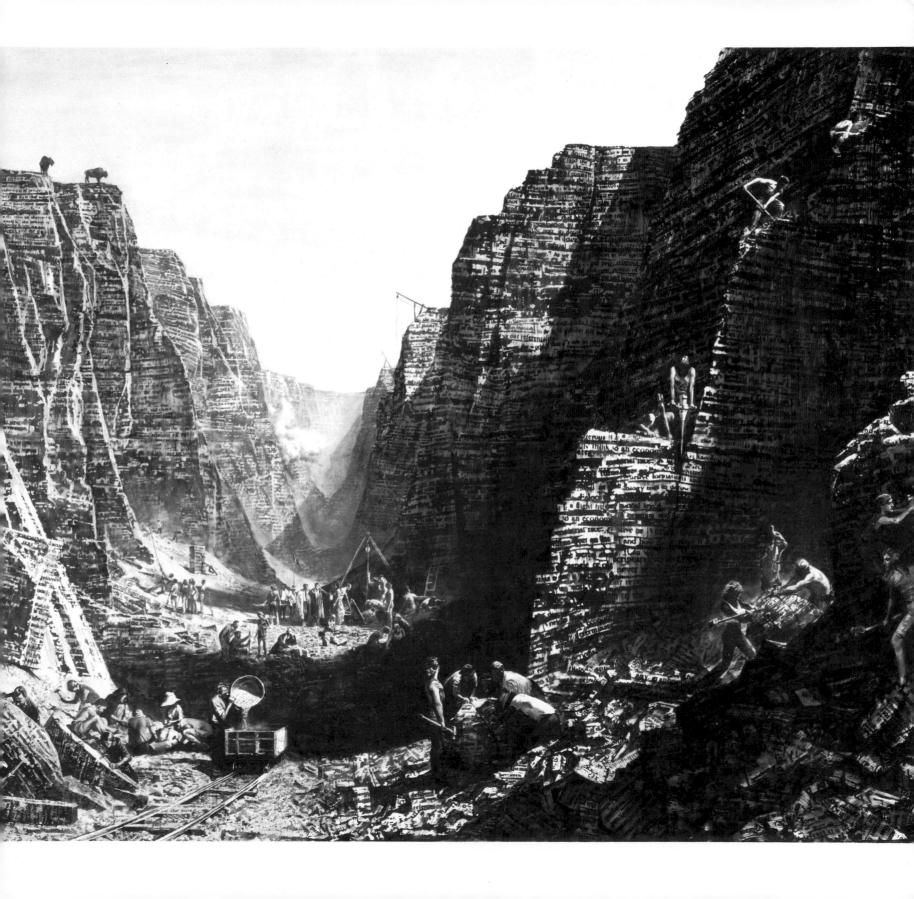

vases. His inking of the screens and his subsequent manipulation of the paint while wet results in further obscuring of the text. Even when he incorporates a collage with text into his *Picasso and Braque*, 1992, the text is indecipherable. The age or the source of the text makes no difference. Its very illegibility is a metaphor for the core belief of the deconstructionists: nothing, in effect, is fixed, there are no organizing structures or anchors, and nothing has a single, certifiable meaning. The very nature of the deconstructionist dialectic and, for that matter, of most theoretical speculation metaphorically expresses the universal need to search, unearth, and ultimately explain. This is precisely the manner in which paintings such as *Under Erasure* and *Close Reading*, integrating these proponents of theory, allude in a very central way to the notion of the quest.

Constructing the Grand Canyon is perhaps the consummate metaphor for the process of investigation in "a world as text," as Tansey characterizes it.[29] Derrida, de Man, Bloom, and Hartman, clustered near the center of the painting, appear with the poststructuralist Michel Foucault, seated on a block near the painting's left edge. They are present at the building of the Grand Canyon, surrounded by those who chisel, hoist, jackhammer, measure, shovel, blast, carve, inscribe. Why? After all, the Grand Canyon is a natural monument created more than 1.5 billion years ago. These "workers" seek to master its "meaning." The sheared, folded, and blurred cliffs of text are unclear; words give texture to these cleaved chunks of earth. Man is dwarfed by these massive forms.

Constructing the Grand Canyon is the ultimate sublime landscape, heir to the American nineteenth-century landscape paintings of Frederick Church or Thomas Cole and to the "textual sublime," straight from the writings of Derrida. Just as the immensity of the Grand Canyon inspires a sense of awe, so too does the abundance of rich content suggested by the dense presentation of text. Tansey at once reinvents Raphael's *School of Athens*, Gustave Courbet's *Artist's Studio*, and Pieter Brueghel's panoramic tableaux of

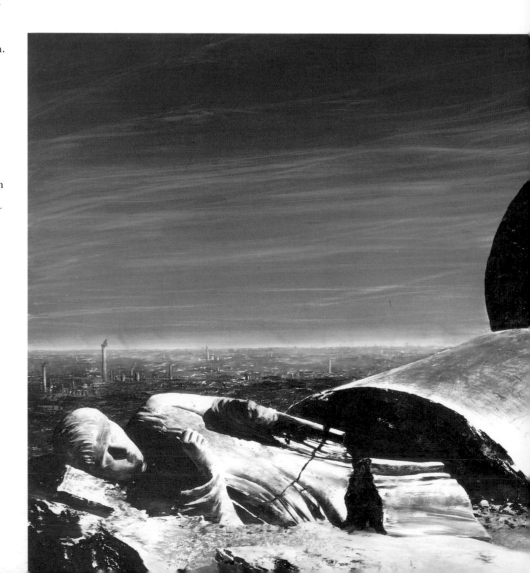

CATALOGUE NUMBER 12

Triumph over Mastery, 1986

Oil and pencil on canvas

59⅞ x 144¼ ins.

(152.1 x 366.4 cm)

The Museum of Contemporary
Art, Los Angeles, gift of Steven
and Patsy Tisch

virtue and vice. That the Yale school substitutes for the likes of Plato and Aristotle is a disquieting commentary on the present state of philosophical inquiry. After all, its representatives are engaged in chipping away at one of the most monumental natural formations in the world, a foolhardy enterprise at best. The viewer may or may not be able to identify this cast of characters. The painting functions allegorically as a profound questioning of the futility of all action in a world of both natural and manmade complexity.

Understanding is also the focus in Tansey's first painting devoted to the theme of the "triumph over mastery" (CAT. NO. 12).[30] This is another in the sublime tradition of Church and Cole. A modern child plays atop a fallen column amid an ancient, ruined city. Nearby a mother and her chastened offspring stand on steps before the broken, abstract forms of the column. The columns' gigantic size dwarfs the figures of two young boys and their mother. Tansey contrasts past and present, old and

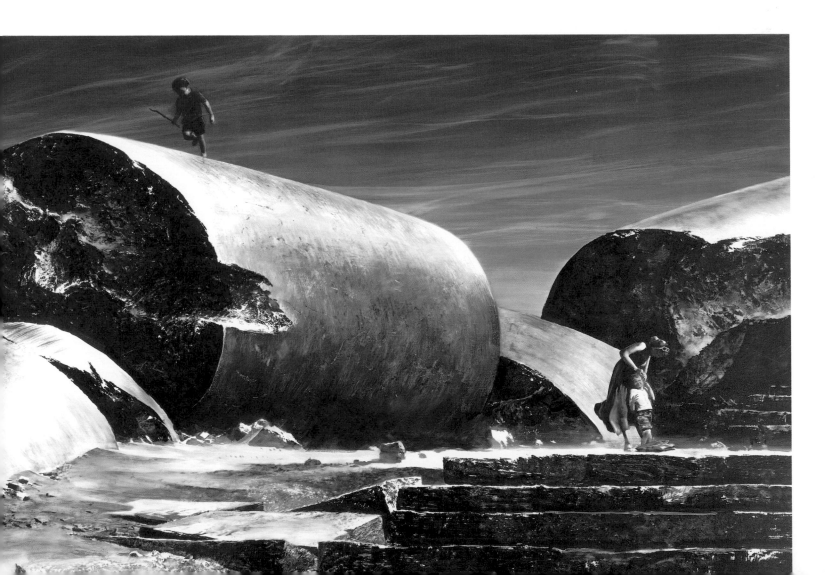

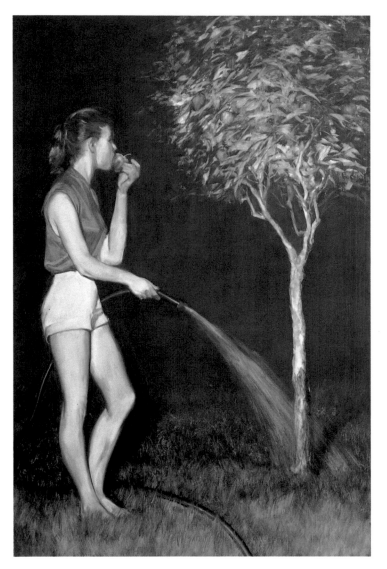

young, dead and alive. The playful, stick-wielding boy conquers this ancient artifact. Just as the Yale school and their companions try to master the Grand Canyon, this boy masters the past. He stands in for the artist; integral to Tansey's search for truth and understanding is his comprehension of the past and its lessons for the future.

The role of the senses in the quest for comprehension has preoccupied Tansey since the early 1980s. "The formalist mythology of Clement Greenberg and his followers, like any good religion, had its prescriptions and prohibitions," Tansey remarked in a public lecture in 1992. "Painting was to be purely optical, flat, static, concrete, irreducible, and unen-

CATALOGUE NUMBER 4

Four Forbidden Senses, 1982
Oil on canvas
58 x 160 ins. (147.3 x 406.4 cm)
Eli Broad Family Foundation,
Santa Monica

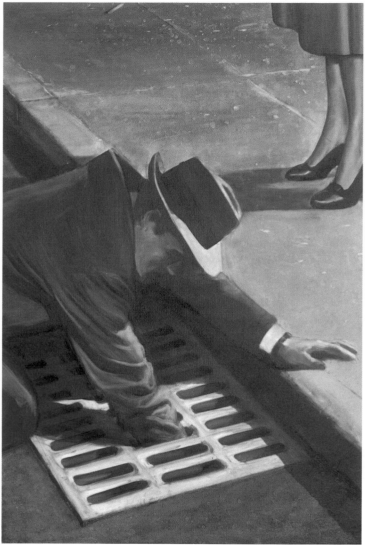

cumbered by memory, illusion, reference, subject mat-
ter, kitsch."[31] Tansey's simultaneous invocation and
sardonic treatment of "four forbidden senses" in
the painting of that title (CAT. NO. 4)—gustatory,
auditory, olfactory, and kinesthetic—bears witness to
his intention to pursue a non-Greenbergian method
of inquiry.

Vision, the remaining, sanctioned sense,
unsurprisingly is the subject of several ironic can-
vases. The protagonist of *Doubting Thomas*, 1986 (CAT.
NO. 10), tentatively fingers a fissure in the road that
eyes alone could easily confirm, while the entire crew
in *Coastline Measure*, 1987 (CAT. NO. 15), by means of
devices simple and sophisticated and against a fear-

Freeman

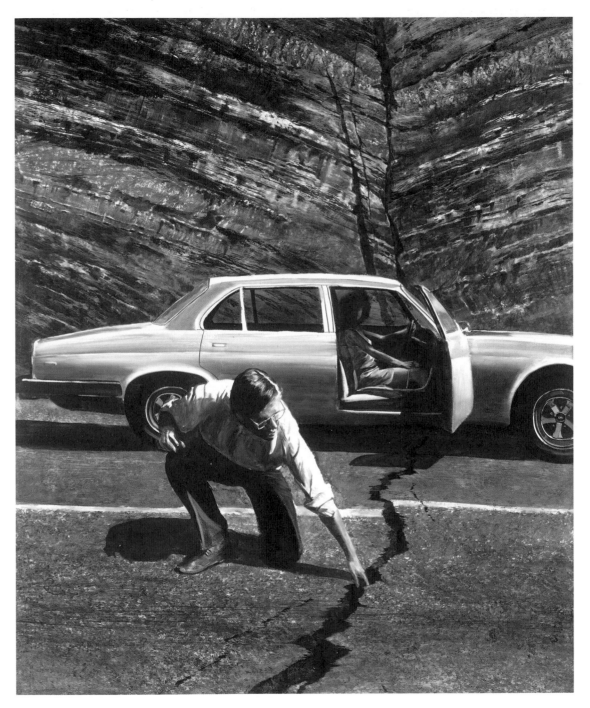

CATALOGUE NUMBER 10

Doubting Thomas, 1986

Oil on canvas

65 x 54 ins. (147.3 x 137.2 cm)

Steve Tisch, Los Angeles

Coastline Measure, 1987

Oil on canvas

87 x 122 ins. (221 x 309.9 cm)

Tom Patchett, Los Angeles

some tide, quantify their observations.

Tansey believes that every image can yield meaning if the viewer makes the effort multisensorily. *Robbe-Grillet Cleansing Every Object in Sight*, 1981 (CAT. NO. 3), depicts the French author and filmmaker Alain Robbe-Grillet in what appears to be a desert, scrubbing stones, which on close view reveal themselves to be, not stones, but monumental miniatures—Stonehenge, the Matterhorn, the Sphinx, the monoliths of Monument Valley—as well as elemental volumes and assorted cultural icons, each representing

general aspects of civilization. Through his determined scrubbing, Robbe-Grillet attempts to strip these stones of their content, no doubt a reference to his wish to remove hidden meanings from every object.[32] Yet Robbe-Grillet's efforts are ultimately as unavailing as those of the deconstructionists in *Constructing the Grand Canyon*. The labor is as arduous, tedious, and unsatisfying as that in Gustave Courbet's emblematic *The Stonebreakers* (1849). His is the consummate form of philosophical inquiry, squeezing meaning out of solid rock.

"Conflict," notes Tansey, "is the easiest notion [from which] to begin developing narrative: one thing versus another. This can be tragic—one thing annihilates another—or comic—one thing versus another—but they end up together anyway."[33] It became apparent to the artist that

crises and conflicts were results of oppositions and contradictions and these were what was necessary to activate or motivate a picture.

Magritte's work also led me to wonder if crisis could take place on other levels of content, more quietly, internally, more plausibly. Could a conventional picture include many less apparent crises—the way everyday life does—without the use of overt surrealistic devices?"[34]

Crossroads and oppositions, particular instances of conflict, represent opportunities in which Tansey can develop two or more of his trajectories. These need not necessarily be crises; they can be merely intersecting or parallel ideas. The concepts resulting from spinning his wheel are made manifest by setting two forces into conflict in a painting.

Conflict and crisis are themes with rich traditions in the history of art. In 1984 Tansey drew a chart, entitled it "Thematic Oppositions as Systems in Conflict," and wrote, "If a theme is based on some sort of conflict (which must be resolved), then it is exactly a matter of an opposition of trajectories or a relation of trajectories. Wherefore: trajectories are the structural components of a theme (for a picture)."[35] Then he provided examples:

silhouetted figure vs. fully-rendered figure

out of focus figure vs. clear figure

fulfilled vs. unfulfilled

conscious vs. unconscious

accidental vs. deliberate

visible vs. invisible

clarity vs. obscurity

control vs. chaos

These oppositions furnished the sources for Tansey's paintings of conflict and crisis. The artist points to *Iconograph 1*, 1984, and *White on White*, 1986 (CAT. NOS. 6 and 13), as experiments in oppositions. "A sort of Lévi-Strauss myth-structure grid for crossing artificial/natural oppositions,"[36] *Iconograph 1* shares much with Magritte's disquieting juxtapositions of word and image or ordinary object in extraordinary scale or circumstances. Tansey considers the painting the forerunner of the wheels; it functions as a grid that invites open-ended speculation within a framework of categories. The painting is a "gameboard" of nine squares containing images that are, as they say, the same but different. A man and ape cup hands and appear to shout in unison; two wooden totem poles; the mouth of a cave, shaped like a face in profile (and painted in a style reminiscent of Magritte), frames a view of the sea; a conservatory of tropical plants; a man rappeling down George Washington's nose (Mt. Rushmore); an armed and camouflaged soldier—each embodies some paradoxical junction (intersecting trajectory) of the natural and the artificial. It is the juxtaposition of images that undermines their consistencies, permitting Tansey to extend Magritte's questioning of the nature of reading and interpretation.[37]

CATALOGUE NUMBER 3

Robbe-Grillet Cleansing Every Object in Sight, 1981

Oil and crayon on canvas

72 x 72¼ ins. (182.9 x 183.4 cm)

The Museum of Modern Art, New York, gift of Mr. and Mrs. Warren Brandt, 1982

CATALOGUE NUMBER 6

Iconograph 1, 1984

Oil on canvas

72 x 72 ins. (182.9 x 182.9 cm)

Courtesy of Curt Marcus

Gallery, New York

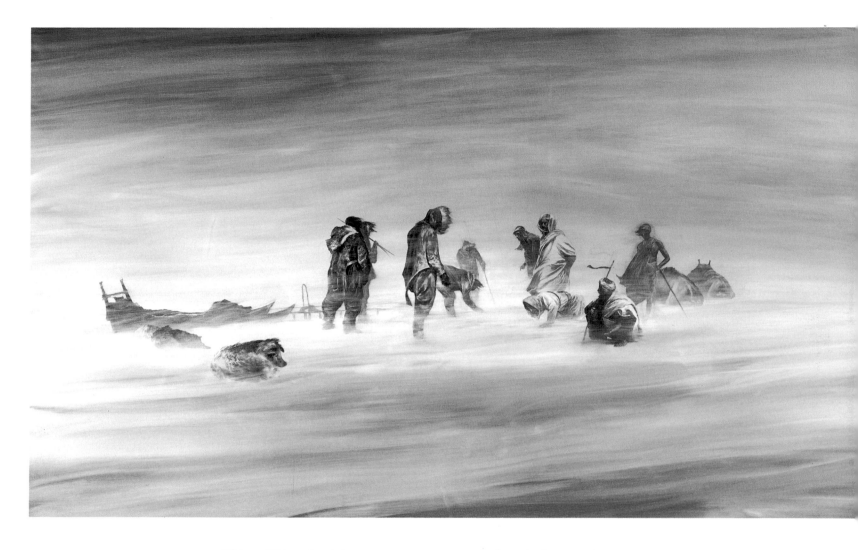

CATALOGUE NUMBER 13

White on White, 1986
Oil on canvas
78 x 138 ins. (198.1 x 350.5 cm)
Collection of Walker Art Cen-
ter, Minneapolis, gift of Charles
and Leslie Herman, 1991

White on White, painted the same year as *Triumph over Mastery*, is a veritable catalogue of oppositions: Inuits and Arabs, cold and hot, north and south, snow and sand, earth and sky, combat and reconciliation.[38] The Inuits (from a *National Geographic* photograph) have arrived on dogsleds; the Arabs (from the same source) have crossed the desert on camelback. Face to face, they seem somehow mutually oblivious. It is not so much that they have turned toward each other as that they have turned away from the fierce winds that send white sand and white snow gusting indistinguishably. The painting has been aptly described as "the ideological erasure of difference accomplished in the mass media, where images of starvation coexist with and are therefore equated to sports reports or other 'happy news.'"[39]

Tansey uses monochrome in *White on White* to enhance this effect. The uniformity of color unifies the picture's disparate elements. "In *White on White*," Tansey has explained, "the cues are drastically mini-

mized (minimal) to give, after the first scan, later readings of dynamic oppositions |that are| wholly different than the original seeming seamlessness."[40]

Oppositions in Tansey's paintings are as conceptual as perception versus actuality (*Doubting Thomas*) or as elemental as two men wrestling. Like Sherlock Holmes when he wrestled Professor Moriarty above Reichenbach Falls in Arthur Conan Doyle's "The Final Problem," an illustration from which is evoked in this scene, Derrida, wrestling de Man both for control of the nuances of deconstructionism and over the flaws in de Man's character, is equally at risk of toppling into the abyss (CAT. NO. 21). The precipice on which they tussle is constructed of pages of printed text drawn from de Man's *Blindness and Insight*. Though de Man had died three years earlier, in 1983, Tansey depicted the philosophers as equally robust combatants "about to be deconstructed to smithereens."[41]

The scene, though realistic in appearance, is wholly contrived, a metaphor concocted in part to illustrate the debate raging over the posthumous revelation in 1987 that de Man had ties to fascists in his native Belgium during World War II. The ensuing outcry from the literary and academic communities prompted Derrida's vigorous defense of his colleague and fellow deconstructionist as well as of deconstructionism itself, which had come, as a result of these damaging allegations, to be suspected of having the potential to mask one ideological allegiance or another.[42] So why is Derrida now wrestling de Man? Because his defense, though impassioned, was often problematic, involving a selective marshalling of

events and documents in support of de Man's integrity. No doubt he was "querying" the de Man he thought he knew as well as the one he did not know at all. The men in the painting, allies and enemies at one and the same time, may be dancing, may be fighting. That they are on the edge of a cliff alludes to the peril of their irresolvable debate and its implications for the assessment of de Man's career and of deconstructionism.

Invariably Tansey's painted conflicts are frozen moments, staged to make multiple allusions. In the earliest such scenes, he used the military as metaphor.[43] *Triumph of the New York School*, 1984 (CAT. NO. 8), appears to be a classic depiction of opposing forces meeting on the battlefield,[44] here the interwar avant-garde of France in their World War I uniforms and the painters and critics of the New York School suitably attired for World War II. Although the composition is based on Diego Velázquez's *Surrender of Breda*, 1635, this is no historic capitulation. André Breton, in the long wool coat with his back to us, signs the document of surrender, witnessed by Clement Greenberg. The School of Paris painters, who dominated the French art scene between the wars, cede their leadership of the avant-garde to the Americans. To Breton's left, Pablo Picasso, dressed in a field officer's fur, appears shell-shocked. The colleagues surrounding him—Salvador Dalí, Henri Rousseau, Juan Gris, Guillaume Apollinaire, André Derain, Henri Matisse, Pierre Bonnard, and Marcel Duchamp—are dressed for battle. The triumphant New Yorkers appear self-assured: Jackson Pollock gazes intently at the scene,

CATALOGUE NUMBER 21

Derrida Queries de Man, 1990

Oil on canvas

83¾ x 55 ins. (212.7 x 139.7 cm)

Collection of Mike and Penny
Winton

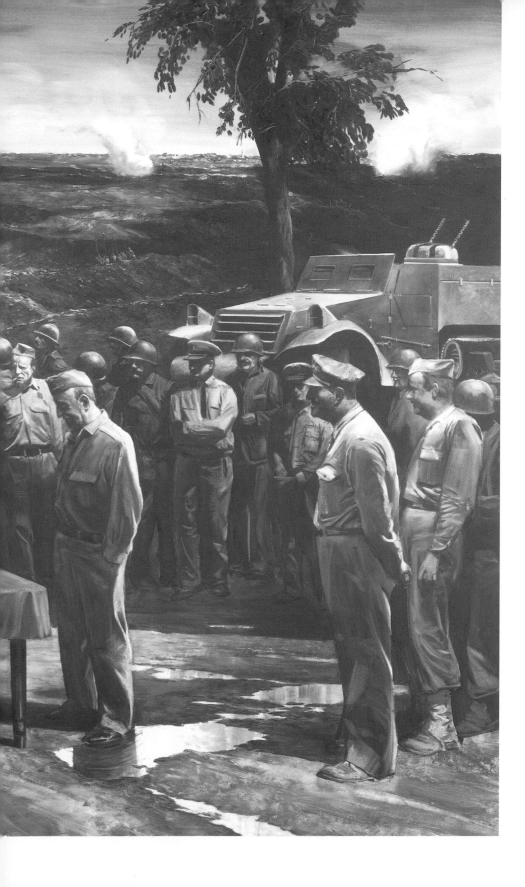

CATALOGUE NUMBER 8

Triumph of the New York School,
1984
Oil on canvas
74 x 120 ins. (188 x 304.8 cm)
Whitney Museum of
American Art, promised gift
of Robert M. Kaye

CATALOGUE NUMBER II

Forward Retreat, 1986
Oil on canvas
94 x 116 ins. (238.8 x 294.6 cm)
Eli Broad Family Foundation,
Santa Monica
(overleaf)

hands in pockets and cigarette hanging from his mouth. In a circle around Greenberg stand Joseph Cornell, Arshile Gorky, Barnett Newman, Ad Reinhardt, David Smith, Willem de Kooning, Mark Rothko, Robert Motherwell, and, directly behind Greenberg, the other prominent voice for the New York School, Harold Rosenberg. The Americans are victorious, thanks to their tanks, their more functional clothing, and their ingenuity. The French are hopelessly mired in their cumbersome formal attire and hampered by their outmoded use of horses. The French and American artists, writers, and critics represent two trajectories engaged in a war of styles.

The expression *avant-garde* translates as "ahead of the guard" or "vanguard." Military in origin, it presupposes a crisis in "the guard," hence the need for something out ahead, and one group triumphing over another. Postwar critical literature in this country considers avant-garde practice to have been dominated by the writings of Clement Greenberg. Tansey, as we know, has been acutely interested in Greenberg's writings. He has taken Greenberg's article "Looking for the Avant-Garde," cut it into pieces and reassembled it, underlining and annotating specific passages.[45] He says that *Triumph of the New York School* is the "art historical battlefield—the pictured field as pictorial field—the site of tactics—strategic maneuvers—fields of paradigmatic exercises."[46] In effect, Greenberg's military rhetoric becomes Tansey's battlefield.

The military analogy for the passage of leadership from one camp to another was also adopted by

Tansey in *Forward Retreat*, 1986 (CAT. NO. 11). The reflections are symbols of the four horsemen of the apocalypse: three soldiers of the Great War in French, German, and British uniforms and a polo player mounted backward gallop forward, their sights set to the rear. An ornate frame and "primitive" mask sink into the murky waters. Tansey is satirizing the avant-garde of the 1980s: the neo-expressionists, neo-primitives, Neo-Geos, and graffiti artists.[47] He describes the image as "reflection as structural metaphor for an art historical present consisting largely of upside down reversed simulations of heroic postures of the recent past."[48] The field on which opposing forces meet, serves as an especially eloquent metaphor for conflict. In *Sola Scriptura*, 1992 (CAT. NO. 27), two forces face off at the entrance to a railroad tunnel. Helmeted French figures to the left, fashionably uniformed SoHo denizens to the right: they symbolize a changing guard in a world of contemporary art, which is not necessarily the better for the change. Both paintings represent, as Thomas Sokolowski aptly observed, "a critique, nay an indictment, mired in the muck of the present, that picks through the art trash of the past and desperately seeks some direction."[49]

So much for the avant-garde vs. the conservative tradition against which it rebelled. What of the inherent conflict between the elitist avant-garde and the contemporary consumers of art? In *Purity Test*, 1982 (CAT. NO. 5), Indians on horseback gaze down from a rocky promontory at Robert Smithson's *Spiral Jetty*, 1970. Smithson had sought to create a pure

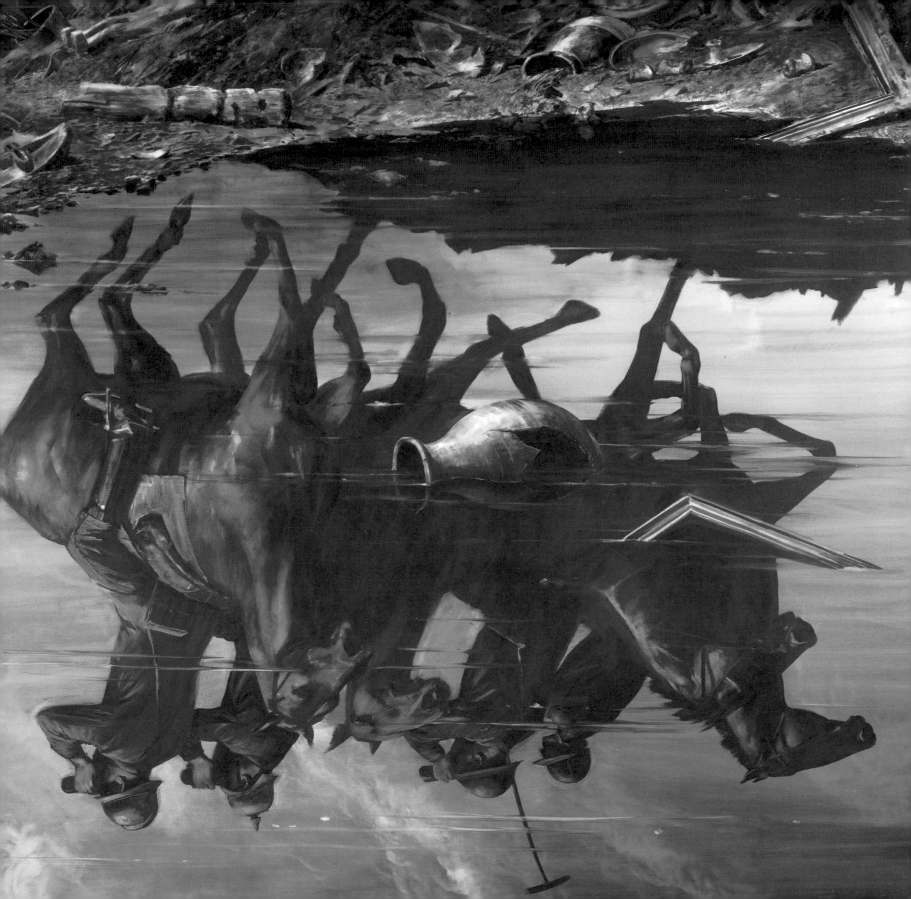

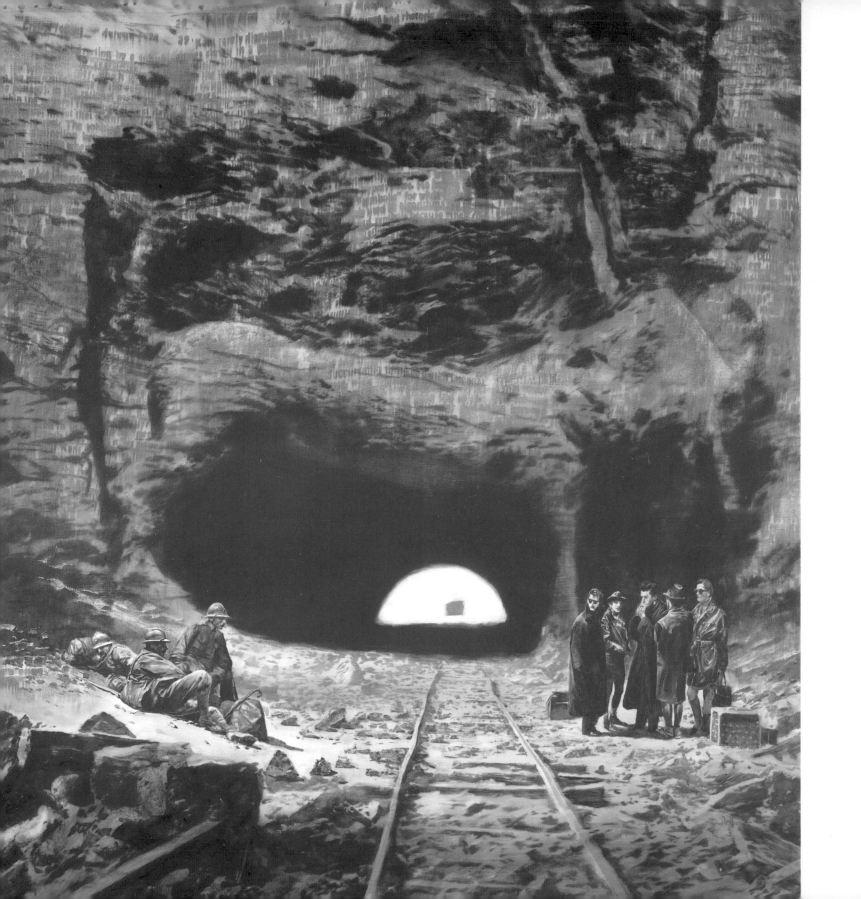

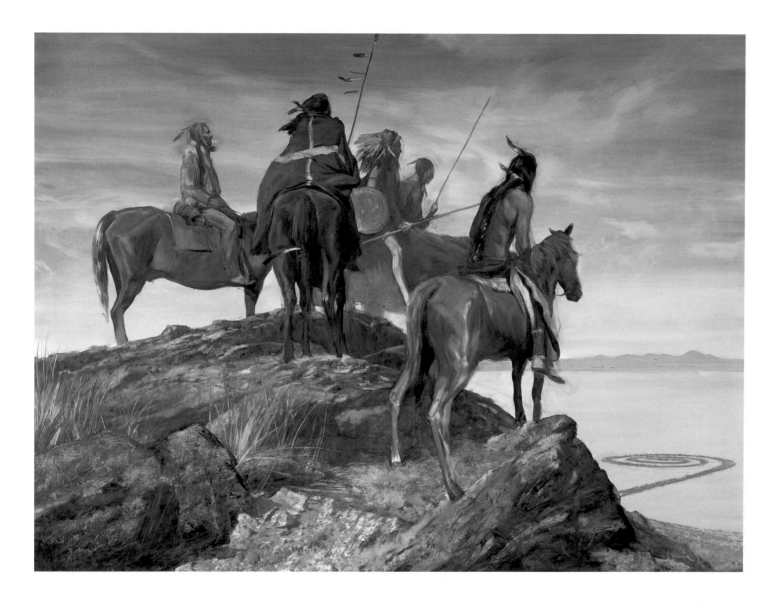

CATALOGUE NUMBER 27

Sola Scriptura, 1992

Oil on canvas

68 x 60 ins. (172.7 x 152.4 cm)

David and Susan Gersh,

Beverly Hills

(left)

CATALOGUE NUMBER 5

Purity Test, 1982

Oil on canvas

72 x 96 ins. (182.9 x 243.8 cm)

Collection of The Chase

Manhattan Bank, N.A.

(above)

CATALOGUE NUMBER 9

Conversation, 1986

Oil on canvas

78 x 110 ins. (198 x 279.4 cm)

Private collection, New York

(overleaf)

image. The Indians, unaware of the spiral's function as a work of art, attempt to decipher it as a symbol instead. These Indians and *Spiral Jetty* clearly did not coexist; instead they come together as two of Tansey's trajectories, not precisely oppositions but irreconcilable forces that meet on a plane.

Because it is a painting by Mark Tansey, one expects something beyond the tranquil poolside garden scene in *Conversation*, 1986 (CAT. NO. 9), an image very much in the tradition of conversation pieces and genre scenes. Beyond the wall the sky is stormy; the trees bend in the wind. The figures differ too. The man on the left leans back, inhaling contemplatively; his companion leans forward rather more tensely, crossing his hands expectantly on his knee. They are hardly talking about the weather.[50] In the reflection on the surface of the pool their postures are somewhat reversed. The conflict once again is between apparent actuality—what occurs on the deck—and an equally, if not more credible, emanation—the images reflected in the pool. As Tansey observes, the very choice of the "verbal theme 'Conversation' offers itself as empty subject or empty frame to what hopefully becomes a pictorial conversation"[51]—in other words, a conversation between the viewer and the painting.

Bridge over the Cartesian Gap, 1990 (CAT. NO. 18), by contrast uses the image of a link, or bridge, to erase all sense of conflict. Tansey believes that the notion of a bridge is central to the consideration of systems in conflict. Among his trajectories he lists the bridge and its subcategories: "the object bridge" versus the "person or event bridging" and "the object bridge not yet in place" versus the "event of bridging preced-

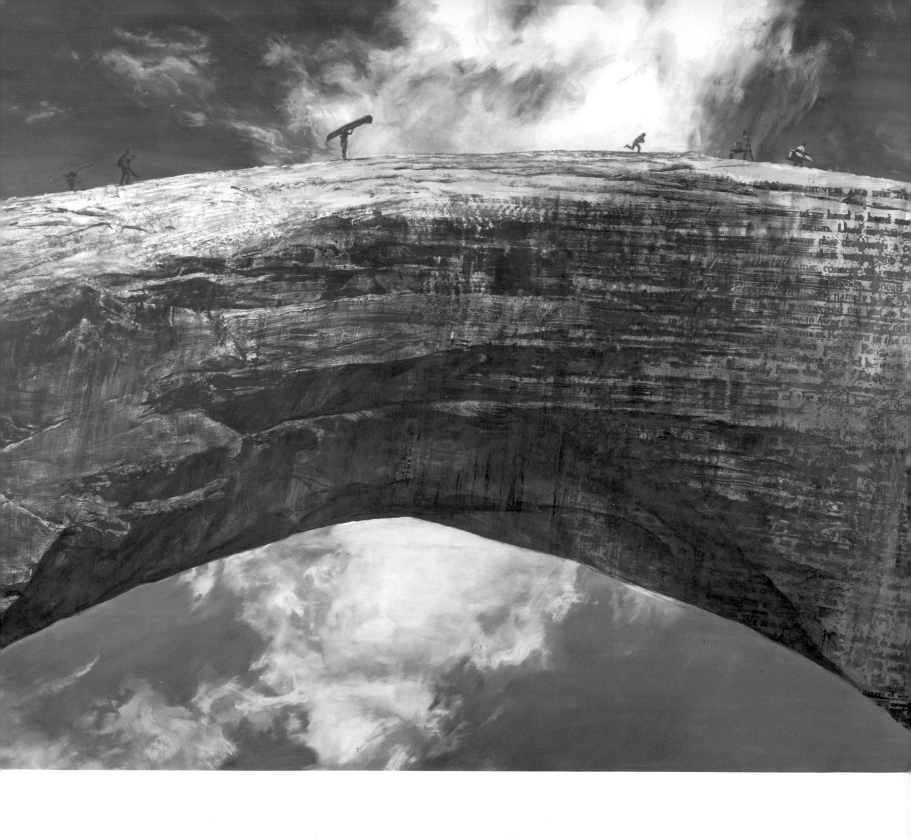

ing the placement of the bridge."[52] The "Cartesian gap" of the title refers to René Descartes's having envisioned a vast bridge that would link bodies of knowledge. A giant natural bridge is constructed from boldfaced and underscored passages from de Man's *Blindness and Insight*—a favored source from which Tansey also drew for *Close Reading*, *Reader*, and *Incursion* of the same year. An assortment of figures dash across the bridge, which symbolically unites all dualities, quelling all conflict.

Tansey writes,

The more I tried to purge violence—the clearer it became how conflict exists on all levels of content, though in unexpected registers. The key was to transform it into productive oppositions, equivocations, inquiries, contrasts, gradations, to find other structures of distinctions, mixings, pulsations, oscillations, weavings, foldings."[53]

Crises and crossroads persisted in several of Tansey's works of 1992 as he continued to address the art world. His systems and convictions developed in large part from his longtime concern about the conditions

of art and art making. We have already considered his skeptical view of theories of flatness and the myth of action painting. As a result of his own education at Art Center College of Design in Los Angeles from 1969 to 1972 and Hunter College from 1974 to 1978, he also became critical of orthodoxy in discussions of art. "My art training," he has remarked, "was like catechism class."[54] And we have also seen that he was not alone; his views were shared by scores of artists and critics.

To express these ideas directly in his work, Tansey initially was heavily didactic. His deployment of imagery from popular magazines baited "high art." *A Short History of Modernist Painting* chronicles the aesthetic developments in such art during the second half of the twentieth century, with an emphasis on the New York School. *Myth of Depth*, 1984 (fig. 6), takes up where his earlier painting left off. From a boat nearby, Kenneth Noland, Helen Frankenthaler (for whom Tansey worked as a studio assistant in the late 1970s), Mark Rothko, a gesturing Clement Greenberg, Arshile Gorky, and Robert Motherwell watch as Jackson Pollock walks on water. They are disciples to

CATALOGUE NUMBER 18

Bridge over the Cartesian Gap,
1990
Oil on canvas
87 x 108 ins. (221 x 274.3 cm)
Private collection

FIGURE NUMBER 6

Myth of Depth, 1984
Oil on canvas
38 x 89 ins. (96.5 x 226.1 cm)
Private collection

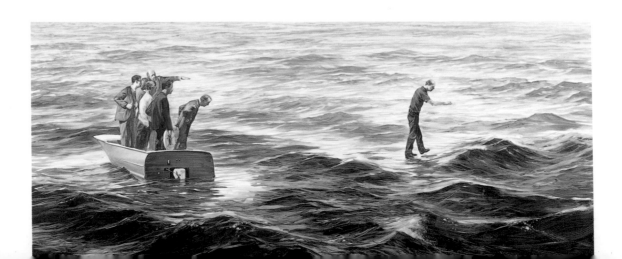

Pollock's Christ: Motherwell considers the depth of the water, Greenberg lectures on flatness, and Gorky holds the life preservers.[55]

In *Action Painting 11* (1984) Tansey takes specific aim at the famous phrase used by Harold Rosenberg to describe the physicality of Pollock, de Kooning, and other members of the New York School at work.[56] Tansey's is a "painting of action," in which ten artists, having witnessed the launch of an American space shuttle, complete their depictions eight seconds after liftoff. Rosenberg's notion and the artificiality of easel paintings are mocked in a single stroke.[57] Both *Forward Retreat* and *Purity Test* raise questions about the progress of the *avant-garde* and its relationship to its audience.

When, on at least three occasions, Tansey painted the profile of Mont Sainte-Victoire, the mountain near Aix-en-Provence made famous by Paul Cézanne, he addressed one of the monuments of modernism. For critics such as Greenberg, Cézanne is the wellspring for virtually all modern art concerned with the flatness of the picture plane. For Tansey his evocation of Cézanne is a way of reasserting his own link with the art of the past; as critic Peter Schjeldahl has observed, "It is hard on artists, on the morale of the creative spirit, to do without the idea of a relevant past."[58] In Tansey's 1987 *Mont Sainte-Victoire* (CAT. NO. 16) the soldiers of poststructuralism and deconstruction—Jean Baudrillard (seated second from left), Barthes (recumbent, lighting a cigarette), and Derrida (standing, removing his overcoat)— disrobe in the shadow of Cézanne's mountain. Shed-

ding their uniforms, they are transformed in their reflections into women. The men on the shore (at left) are flanked by the arching trees of Cézanne's 1906 *Bathers*. All appear engulfed in the depths of Plato's murky cave. Aided by Derrida's 1978 book *Spurs: Nietzsche's Styles*, Tansey explores the nature of representation through a study of transformation. The mountain is metamorphosed into a cave; its reflection becomes a lake. Men become women; clouds become rocks. The horizon, now reversed, becomes the ground plane of the composition. The metamorphosis of everything into something else is optimistically suggestive of the possibilities for painting since Cézanne, possibilities other than those suggested by Greenberg and his cohorts.[59]

An assault on the seriousness with which art is taken underlies *The Innocent Eye Test*, 1981 (CAT. NO. 2).[60] In what appears to be a gallery Paulus Potter's *The Young Bull*, 1647, unframed and placed alongside one of Claude Monet's grainstacks, is unveiled for a cow. The cow gazes at a realistic image of one of its kind as art historians, supervising the experiment, watch attentively. One dressed in a technician's smock records his observations. Another grasps a mop. In Tansey's painted metaphor for the perception of art, we are the cow, and the scientists want to know how and what we see—hardly the stuff of Frank Stella's famous dictum "What you see is what you see."

Such allegories gained in complexity the more Tansey immersed himself in critical texts. Compared with the literal assessment of depth taking place in *Myth of Depth*, pictorial depth is more subtly refer-

CATALOGUE NUMBER 16

Mont Sainte-Victoire, 1987

Oil on canvas

100 x 155 ins. (254 x 393.7 cm)

Courtesy of Thomas Ammann, Zurich

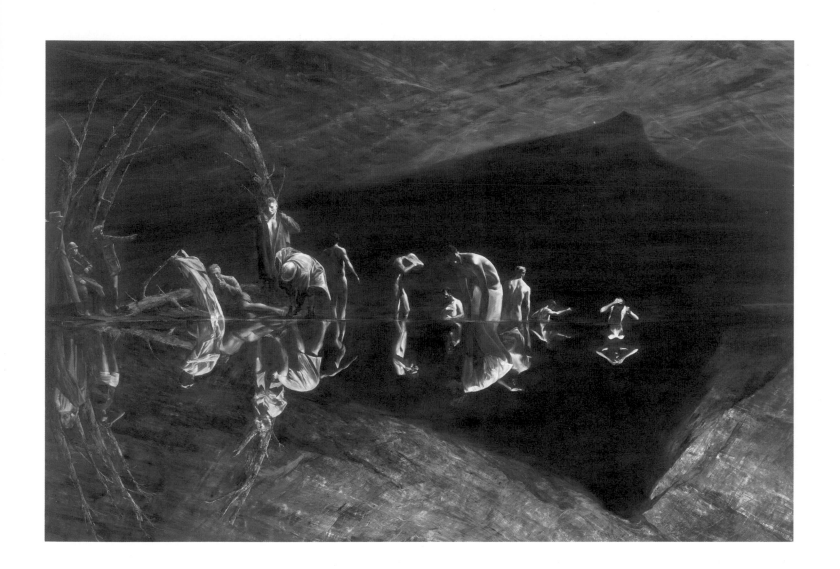

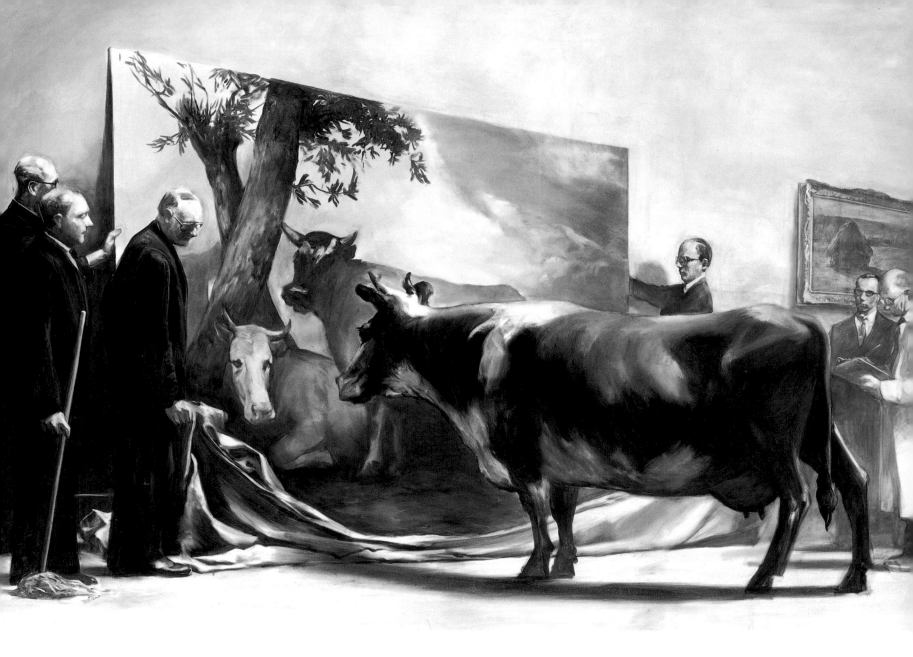

enced in *Triumph over Mastery II*, 1987 (CAT. NO. 17), by the whitewasher obliterating in a single plane Michelangelo's *Last Judgment*, his own shadow, and that of the ladder on which he stands.

 The Source of the Loue, 1990 (CAT. NO. 23), takes the opposite tack. As principal settings of *Myth of Depth II* (1987) and *The Bricoleur's Daughter* caves are a favored motif in Tansey's work, frequently

linked with his interest in Plato's Allegory of the Cave. Here the cave, borrowed, as is the painting's title, from the late landscapes of Gustave Courbet, has been recast as a military installation, a scene of confinement, unbreachable walls, and spirals of barbed wire. Workers, overseen by soldiers, block the entrance to a cave by erecting a wall. Is this Tansey's metaphor for the contemporary art world? All of its

CATALOGUE NUMBER 2

The Innocent Eye Test, 1981
Oil on canvas
78 x 120 ins. (198.1 x 304.8 cm)
The Metropolitan Museum of
Art, New York, promised gift
of Charles Cowles, in honor of
William S. Lieberman, 1988

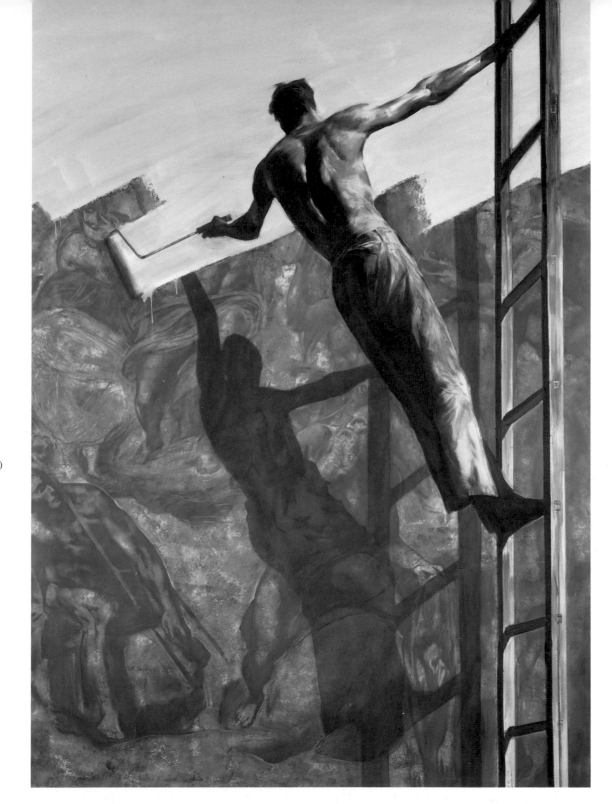

CATALOGUE NUMBER I7

Triumph over Mastery II, 1987

Oil on canvas

98 x 68 ins. (248.9 x 172.7 cm)

Emily Fisher Landau,

New York

The Source of the Loue, 1990

Oil on canvas

65 x 81 ins. (165.1 x 205.7 cm)

Sandra and Gerald Feinberg

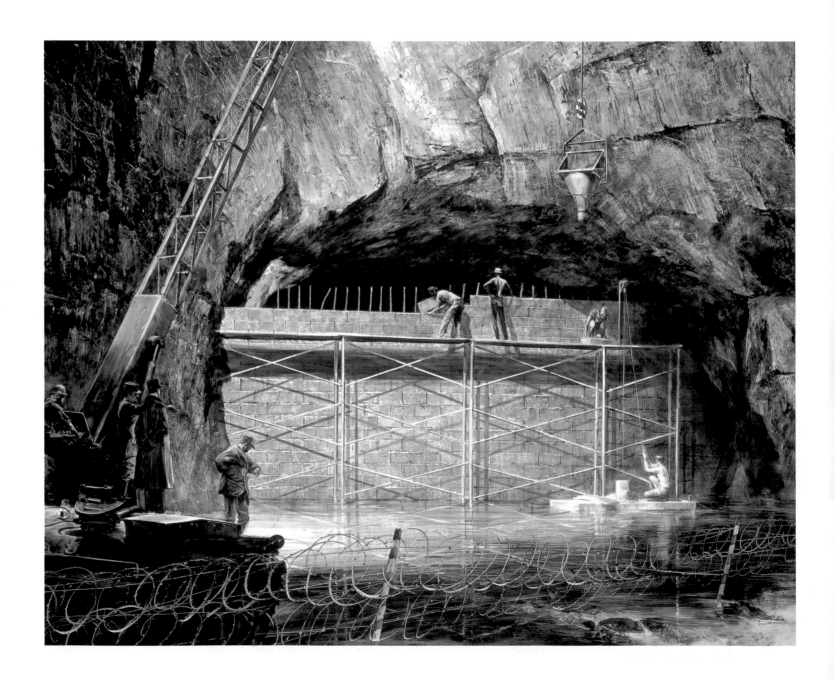

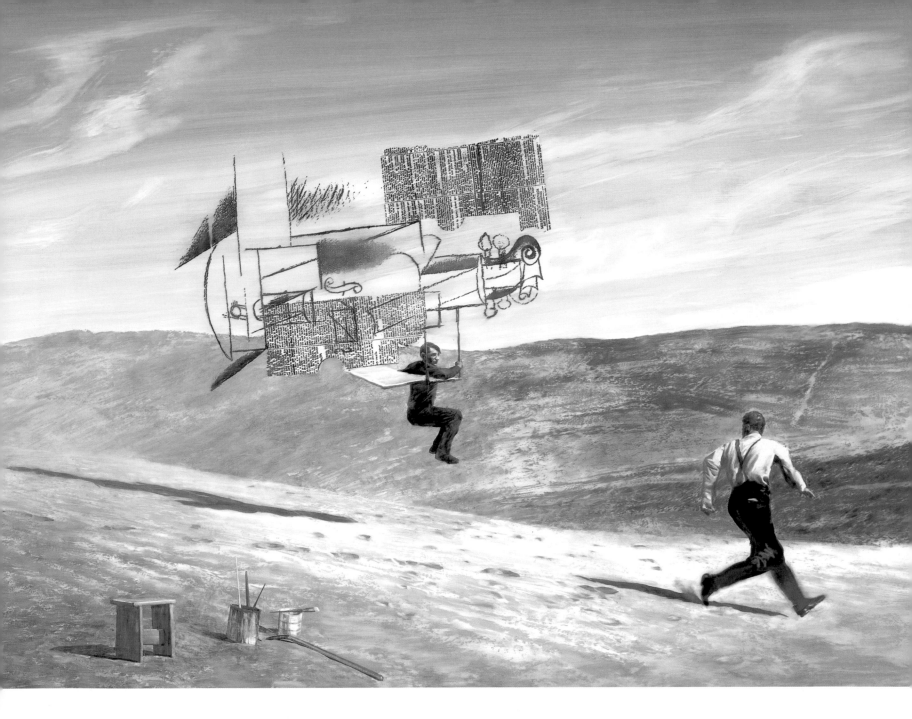

CATALOGUE NUMBER 26

Picasso and Braque, 1992

Oil on canvas

84 x 64 ins. (213.4 x 162.6 cm)

Los Angeles County Museum
of Art, Modern and Contem-
porary Art Acquisitions Fund

theoretical rules and ideologies are represented here by the block wall under construction, which obscures the open-ended explorations of the nineteenth-century *avant-garde*, epitomized by Courbet's cave.

The more elusive reference to art history and criticism is replaced by more direct appropriations in several of Tansey's 1992 paintings.[61] *Picasso and Braque* (CAT. NO. 26) casts the artists as the aeronautical pioneers Orville and Wilbur Wright. Picasso is in flight, Braque running in tandem, looking up and back at his colleague. Their aircraft resembles the Wright brothers' model but, in fact, consists of a silk-

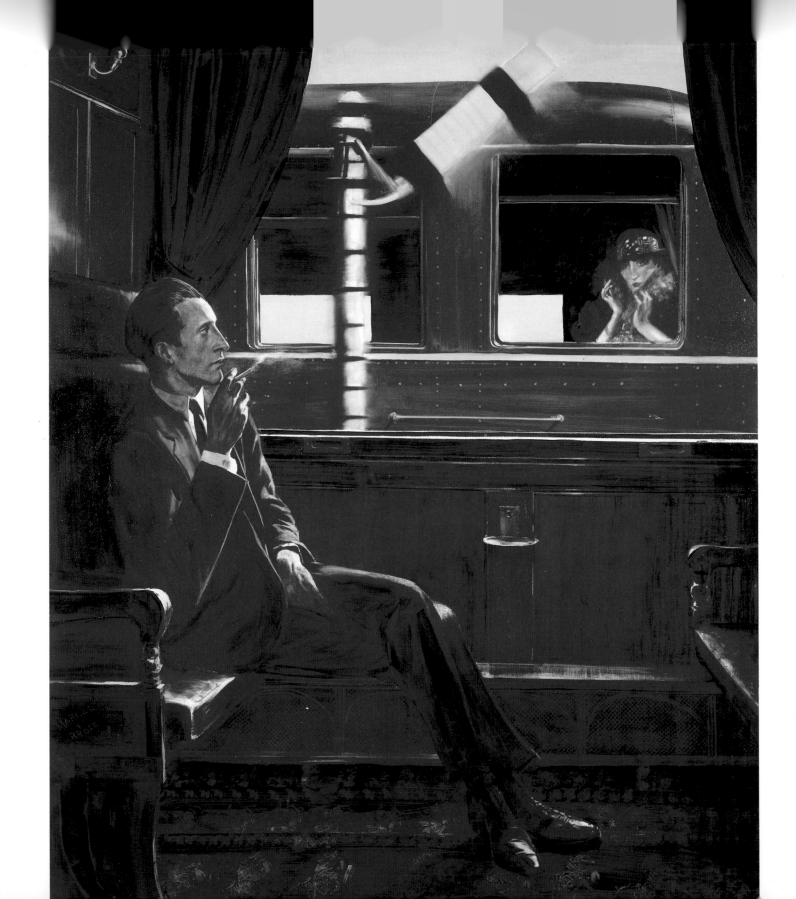

screened rendering of a Picasso collage.[62] The association of Picasso and Braque with the Wright brothers —the artists actually addressed each other as Orville Picasso and Wilbourg Braque—was so prominent a trope of the 1989 Museum of Modern Art exhibition *Picasso and Braque: Pioneering Cubism* that the military analogy elsewhere prevalent in writing on the avant-garde was on the occasion replaced by the vocabulary of discovery.

Picasso and Braque suggests a variety of questions about the nature of representation, innovation, and the avant-garde. Were the possibilities inherent in collage on a par with those associated with the revolution of flight? Were Picasso and Braque "brothers" in a partnership comparable with that of Orville and Wilbur? Was the first plane held together as tenuously as the fragments of Picasso's collage? Or was the invention of flight as hotly debated as the innovation of both cubism and collage? The setting offers no clue as to time or place. Is it specific to Picasso and Braque and the Wrights, or is it equally applicable to all innovators?

The Enunciation, 1992 (CAT. NO. 24), is another painting in which the heroic myths of early twentieth-century art, so essential to formalist as well as modernist and postmodernist theory, are thrown into question. In the flash of two trains passing, Marcel Duchamp, smoking in the foreground on one, glimpses Rrose Sélavy, his alter ego, on the other. Tansey considers Duchamp the "Einstein of art"; in paying homage to him he makes unprecedented use of an acidic purple monochrome chosen in part

because of its name, rose violet.[63] Duchamp's relationship to Rrose Sélavy was on one level that of naming or "enunciating"; the moment depicted is when he invented the readymade and "enunciated" himself, creating his Rrose Sélavy persona. Tansey's painting underscores the pretense of all of this while paying homage by using the very same representational mode of painting that Duchamp sought to declassify.

Shortly before this writing Tansey completed *Leonardo's Wheel*, 1992 (CAT. NO. 25), in the uncharacteristically brief period of two days. He counts it among his most intuitive works: least labored and perhaps most self-referential. There are two small figures, but they are dominated by the whirling, gyrating wheel. As it "belongs" to da Vinci, its reference is to the Renaissance artist's engineering activities, though Tansey affirms that it also represents a pictorial analogue of his own wheels. Given the water, clouds, and smoke this wheel generates, one wonders what comment Tansey is making on the value of the device.

Leonardo's Wheel brings Tansey's work full circle. The wheel is also the image from which his 1992 drawings, created expressly for this volume, emanate. Made of photocopy toner or graphite, the drawings begin with natural forces processed through Leonardo's wheel and end with Niagara Falls, the quintessentially unbridled natural force. Grouped into suites—Wheels, Frameworks, and Nocturnes— the drawings extend the artist's preoccupation with notions of questing, crises, and the nature of art.

CATALOGUE NUMBER 24

The Enunciation, 1992
Oil on canvas
84 x 64 ins. (213.4 x 162.6 cm)
Museum of Fine Arts, Boston, Ernest Wadsworth Longfellow Fund, the Lorna and Robert M. Rosenberg Fund, and additional funds provided by Bruce A. Beal, Enid L. Beal, and Robert L. Beal, Catherine and Paul Buttenwieser, Griswold Draz, Joyce and Edward Linde, Vijak-Mahdavi and Bernardo Nadal-Ginard, Martin Peretz, Mrs. Myron C. Roberts, and an anonymous donor

The predominance of themes of searching, strug-
gling, and questioning the nature of art in Tansey's
allegories underscores the seriousness with which he
takes his content. Clearly he has been and continues
to be committed to the reassertion of pictorial con-
tent. He holds his audience in high regard, expecting
the maximum effort to decipher what are admittedly
challenging tableaux and encouraging his viewers to
find the tools to make his pictures meaningful. As
the complexity of Tansey's work increases, however,
the issues developed in the three strands examined
here remain constant. His is an infinite "chain of
solutions," and he is the archaeologist cum
philosopher-painter.

CATALOGUE NUMBER 25
Leonardo's Wheel, 1992
Oil on canvas
92½ x 92½ ins. (235 x 235 cm)
Louisiana Museum of Modern
Art, Humlebaek, Denmark

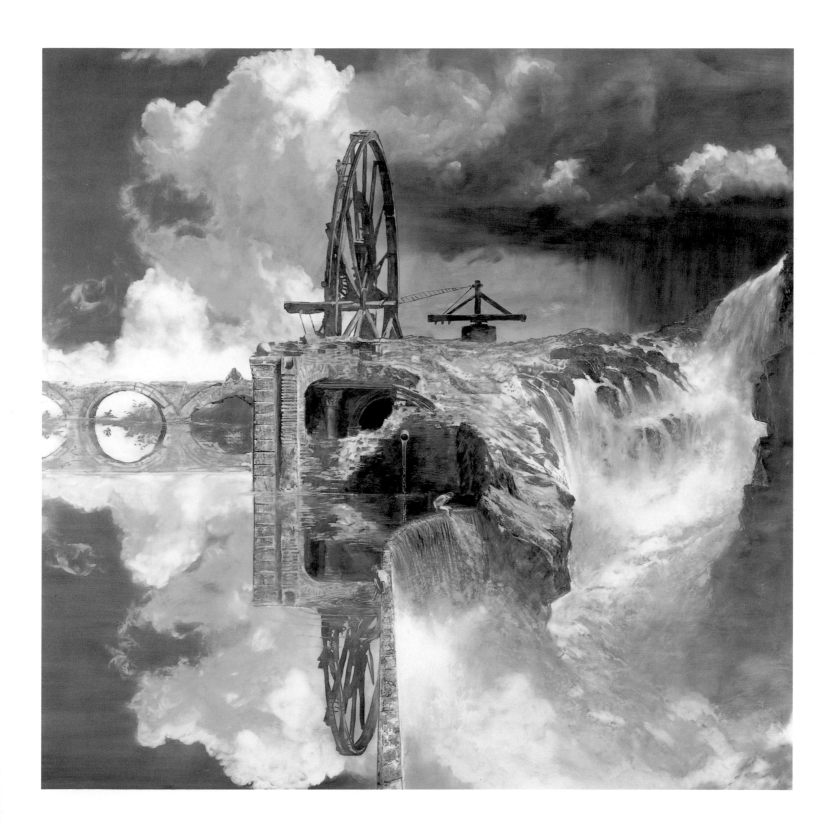

NOTES

1. It is worth recalling that among the most widely discussed articles in the mid-1970s was Linda Nochlin's insightful "The Realist Criminal and the Abstract Law," *Art in America* 61, no. 5 (September-October 1973): 54–61.

2. Robert Pincus-Witten, for example, considered Tansey to be a representative of a new romanticism that emerged during the late 1970s and early 1980s, also characteristic of the work of Ross Bleckner, David Deutsch, April Gornik, Joan Nelson, Holt Quentel, and Mike and Doug Starn. Pincus-Witten, "Entries: Concentrated Juice & Kitschy Kitschy Koons," *Arts Magazine* 63, no. 6 (February 1989): 34.

3. David Salle, "New Image Painting," *Flash Art*, no. 88–89 (March–April 1979): 40.

4. Mark Tansey, "Notes and Comments," in Arthur C. Danto, *Mark Tansey: Visions and Revisions* (New York: Harry N. Abrams, 1992), p. 134; hereafter, Danto.

5. Mark Tansey, interview with the author, 21 November 1990.

6. Patterson Sims, *Mark Tansey: Art and Source*, exh. cat (Seattle: Seattle Art Museum, 1990), p. 12; hereafter, Sims.

7. George Kubler, *The Shape of Time: Remarks on the History of Things* (New Haven: Yale University Press, 1962), p. 33.

8. Danto, p. 128. Tansey covers a gessoed canvas with oil paint of a single color, then removes paint to determine an image.

9. Tansey prefers 1940s and 1950s material, having found that media of that period possessed a more "in-depth sense of the kind of human being that was represented and more variety in terms of style." Tansey, interview with the author, 21 January 1991.

10. Tansey, interview with the author, 21 November 1990.

11. Tansey, interview with the author, 21 January 1991.

12. Tansey, unpublished notes, June 1991.

13. Many of the phrases contained in his wheels originate in the writings of Danto, Paul de Man, Jacques Derrida, and Richard Rorty. Tansey, interview with the author, 21 January 1991.

14. Tansey, unpublished notes, June 1991.

15. Douglas Crimp, "Pictures," in Brian Wallis, ed., *Art after Modernism: Rethinking Representation* (New York: New Museum of Contemporary Art and David R. Godine, 1984), p. 186.

16. Although they perhaps ought to be labelled "reallegories." According to Thomas W. Sokolowski, who organized the 1983 exhibition *Reallegory*,

"Reallegory" (re: repeat, re: about, real, allegory) is a contemporary trend which responds to the popularly-held criticism that modern art is either facile and simplistic or dense, esoteric and mute. The "Reallegory" artists have selected realistic style for its familiarity and accessibility, and have adopted the allegorical mode for its capacity to communicate a timeless complexity of messages. They aspire to a rarely attained aesthetic middle ground where virtuosity and artifice serve up poetry and politics for all takers

"Reallegory" is another step in the continuing evolution of "art about art" (a "hall of mirrors" extension of "art about life"). Through it, traditional symbols and motifs are excised from their original sources and recontextualized. New meaning is achieved while old meaning is reconstituted. "Reallegory" allegorizes allegory.

Reallegory, exh. bro. (Norfolk, Virginia: The Chrysler Museum, 1983), [2].

17. Craig Owens, "The Allegorical Impulse: Toward a Theory of Postmodernism," *October* 12 (Spring 1980): 67–86; and 13 (Summer 1980): 69.

18. Jerry Saltz, Roberta Smith, and Peter Halley, *Beyond Boundaries: New York's New Art* (New York: Alfred van der Marck, 1986), p. 128.

19. Tansey has acknowledged that he is much like Magritte in other ways too: "Magritte's work also led me to wonder if crisis could take place on other levels of content, more quietly, internally, more plausibly. Could a conventional picture include many less apparent crises— the way everyday life does—without the use of overt surrealistic devices? Danto, p. 134.

20. Roland Barthes, "Change the Object Itself," in *Image-Music-Text*, trans. Stephen Heath (New York: Hill and Wang, 1977), p. 167.

21. Tansey, unpublished notes on *Secret of the Sphinx*, 1984, June 1991.

22. Tansey, quoted in Sims, p. 26.

23. Paul de Man, *Blindness and Insight: Essays in the Rhetoric of Contemporary Criticism*, rev. ed. (Minneapolis: University of Minnesota Press, 1983 [originally published in 1971]), p. 141.

Danto compares de Man's text with Tansey's painting without confirming Tansey's knowledge of the text. He alludes to the first chapter of de Man's book, in which the philosopher discusses "close reading," and subsequently to Jacques Derrida's reading of Jean-Jacques Rousseau. Danto concludes, "So my sense is that the 'text' on the rockface is de Man on Derrida on Rousseau on language." Danto, pp. 28–29.

My own inclination is to doubt that Tansey would be so literal about such references. The artist himself has intimated that the text used on the surface of the cliffs is from de Man's *Blindness and Insight*. Tansey, interview with the author, 14 August 1992.

24. Volumes include Maurice Blanchot, *The Gate of Orpheus and Other Literary Essays*, trans. Lydia Davis (Barrytown, New York: Station Hill Press, 1981), *Vicious Circles: Two Fictions and "After the Fact,"* trans. Paul Auster (Barrytown, New York: Station Hill Press, 1985), *The Writing of the Disaster*, trans. Ann Smock (Lincoln: University of Nebraska Press, 1986); several volumes by Jacques Derrida: *Of Grammatology*, trans. Gayatri Chakravorty Spivak (Baltimore: Johns Hopkins University Press, 1976), *Spurs: Nietzsche's Styles*, trans. Barbara Harlow (Chicago: University of Chicago Press, 1979), *Dissemination*, trans. Barbara Johnson (Chicago: University of Chicago Press, 1981), *Glas*, trans. John P. Leavey, Jr., and Richard Rand (Lincoln: University of Nebraska Press, 1986), *The Truth in Painting*, trans. Geoff Bennington and Ian McLeod (Chicago: University of Chicago Press, 1987); Jürgen Habermas, *The Philosophical Discourse of Modernity: Twelve Lectures*, trans. Frederick Lawrence (Cambridge, Massachusetts: MIT Press, 1987); Claude Lévi-Strauss, *The Savage Mind* (Chicago: University of Chicago Press, 1966); Jean-François Lyotard, *Driftworks* (New York: Semiotext[e], 1984); Christopher Norris, *Deconstruction: Theory and Practice* (London: Methuen, 1982); and Richard Rorty, *Contingency, Irony, and Solidarity* (Cambridge: Cambridge University Press, 1989).

In addition Jörg-Uwe Albig has noted that among Tansey's readings of theoretical mathematics and science are James Gleick, *Chaos: Making a New Science* (New York: Viking Press, 1987); Benoit B. Mandelbrot, *The Fractal Geometry of Nature* (San Francisco: W. H. Freeman, 1982); Heinz-Otto Peitgen and P. H. Richter, *The Beauty of Fractals: Images of Complex Dynamical Systems* (Berlin/New York: Springer-Verlag, 1986); and A. E. R. Woodcock and Monte Davis, *Catastrophe Theory* (New York: E. P. Dutton, 1978). Albig, "Ein Denker malt Kritik," *Art: Das Kunstmagazin*, no. 4 (April 1988): 36–54.

25. In the mid-1980s Tansey, Jack Barth, critic Douglas Blau, and artists John Bowman (whom Tansey first contacted after seeing his 1985 exhibition at White Columns in New York) and Robert Yarber met informally to discuss aesthetic issues as well as critical texts (Douglas Blau, interview with the author, 2 July 1992). Later he joined Yarber, art historian Romy Golan, critic and philosopher Michael Kelly, and others in a reading group.

26. Danto, pp. 131–32.

27. See Derrida, *Of Grammatology*, passim. *Under Erasure* is reproduced in Danto (p. 115).

It is also worth noting that the overstrike is now a common feature in many word-processing programs, evidence that deconstructionist technique has made it into the high-technology world of the computer program.

28. For example, *Bridge over the Cartesian Gap*, *Close Reading*, *Constructing the Grand Canyon*, *Reader*, *Valley of Doubt*, and especially *Derrida Queries de Man* (all 1990), and *Archive* (1991). Quite the reverse occurs in *Triumph over Mastery II* (1987), where a painter literally effaces Michelangelo's *Last Judgment*. See also Tansey's reference to Derrida in this context in Danto, p. 132.

29. Mark Tansey, interview with the author, 23 October 1992.

30. For an excellent reading of this painting, see Richard Martin, "Mark Tansey's *Triumph over Mastery*," *Arts Magazine* 62, no. 6 (February 1988): 23–25.

31. Tansey, lecture delivered at Harvard University, 22 October 1992. I am grateful to Mark Tansey for providing me with a text of this lecture.

An interesting counterpoint to Tansey's pro-illusionist views appears in an essay analyzing charges of illusionism leveled at traditional forms of representation by various modernist and postmodernist critics; see Noël Carroll, "Anti-Illusionism in Modern and Post-Modern Art," *Leonardo* 21, no. 3 (1988): 297–304.

32. Alain Robbe-Grillet, *For a New Novel: Essays on Fiction*, trans. Richard Howard (New York: Grove Press, 1965).

33. Tansey, unpublished notes on crisis and conflict, June 1991.

34. Tansey, in Danto, p. 134.

35. Tansey, chart: "Thematic Oppositions as Systems in Conflict; Trajectories—Opposites as Themes," September 24, 1984.

36. Tansey, in Danto, p. 134.

37. On Magritte's word-image device used in this manner, see Judi Freeman, "Layers of Meaning: The Multiple Readings of Dada and Surrealist Word-Images," *The Dada & Surrealist Word-Image*, exh. cat., Los Angeles County Museum of Art, 1989, pp. 46–50.

38. For a detailed discussion of *White on White*, see Sims, pp. 16–17.

39. David Joselit, "Milani, Innerst, Tansey," *Flash Art*, no. 134, May 1987, p. 101.

40. Tansey, unpublished notes on monochrome painting, June 1991.

41. Danto, p. 29. Tansey has indicated that he was particularly interested in Derrida's lengthy published apologia defending de Man. Interview with the author, 15 October 1992.

42. For a detailed account of these events, see David Lehman, *Signs of the Times: Deconstruction and the Fall of Paul de Man* (New York: Poseidon, 1991).

43. In many ways the association of conflict, sportsmanship, and battle with histories of civilization is also central to the recent writings of Kirk Varnedoe and his analogy between the game of rugby and modern art. See Varnedoe, *A Fine Disregard: What Makes Modern Art Modern* (New York: Harry N. Abrams, 1990), especially pp. 9–11.

44. This painting is discussed extensively by both Thomas Kellein ("Blindness and Insight: Mark Tansey's Questioning of Our Understanding of the Perception of Art," *Mark Tansey*, exh. cat. [Basel: Kunsthalle, 1990], [6]) and Danto (pp. 20–21).

45. Clement Greenberg, "Looking for the Avant-Garde," *Arts Magazine* 52 (November 1977): 86–87. A photocopy of this article in Tansey's archives is extensively underscored and annotated by the artist.

46. Tansey, unpublished notes, 1984.

47. German neo-expressionists were also Tansey's target in *Occupation* (1984), in which German soldiers of the First World War land at the corner of Spring Street and West Broadway in New York's SoHo district, figuratively taking the 1980s art scene by force.

48. Tansey, notes distributed in conjunction with his 1986 exhibition at Curt Marcus Gallery.

49. Thomas W. Sokolowski, *Morality Tales: History Painting in the 1980s*, exh. cat. (New York: Grey Art Gallery, New York University, 1987), p. 9.

50. For a most suggestive interpretation of the nature of conversation prompted by a viewing of this painting, see Douglas Blau, "Where the Telephone Never Rings: Tansey's *Conversation*, 1986," *Parkett*, no. 13 (1987): 34–39.

51. Tansey, notes on *Conversation* distributed at the Curt Marcus Gallery when the painting was shown there in 1987.

52. Tansey, "Thematic Oppositions and Systems in Conflict" (unpublished ms.). These phrases also appear on several of Tansey's wheels. It is worth noting that Jack Barth, a contemporary and friend of Tansey, devoted several 1989 paintings and drawings to the motif of bridges. See *Jack Barth*, exh. cat. (New York: BlumHelman Gallery, 1989); essay by Douglas Blau.

53. Tansey, unpublished notes on crisis and conflict, June 1991.

54. Tansey, quoted in Albig, "Ein Denker malt Kritik," 47. Integral to Tansey's art education were his parents' professions. His father is an art historian; his mother, a slide librarian.

55. I am indebted to notes by Christopher Sweet for this interpretation.

56. The painting is reproduced in Danto, pp. 62–63.

57. The same may be said for Tansey's *End of Painting*, 1984 (reproduced in Danto, p. 67), in which an image of a motion-picture cowboy firing at his own reflection in a mirror appears to be projected onto a home-movie screen.

58. Peter Schjeldahl, *The Hydrogen Jukebox: Selected Writings of Peter Schjeldahl 1978–1990* (Berkeley: University of California Press, 1991), p. 1.

59. On this painting, see Richard Martin's excellent commentary in "Cézanne's Doubt and Mark Tansey's Certainty on Considering *Mont Sainte-Victoire*," *Arts Magazine* 62, no. 3 (November 1987): 79–83.

60. The notion of an innocent eye may have originated in the nineteenth century with John Ruskin, who conceived the innocence of an eye that would be able to overlook whatever impeded the perception of truth. See Danto, p. 18.

61. *Authentication*, 1992, has as its subject the silkscreens of Andy Warhol; Tansey actually used a discarded Warhol screen to recreate the image of Warhol's *Flowers* (1965–67) in the painting.

62. The collage is *Violin* (after December 1912), charcoal and paper mounted on a paper support, 24⅛ x 18½ in. (61.9 x 47 cm), Musée National d'Art Moderne, Centre Georges Pompidou, Paris.

63. Tansey, interview with the author, 8 May 1992. Tansey indicated that he was particularly taken with the writings of Thierry de Duve on Duchamp, especially his most recent book, *The Definitively Unfinished Writings of Marcel Duchamp* (Cambridge, Massachusetts: MIT Press, 1991), in which he discusses Duchamp's moment of revelation, to which Tansey refers in his painting.

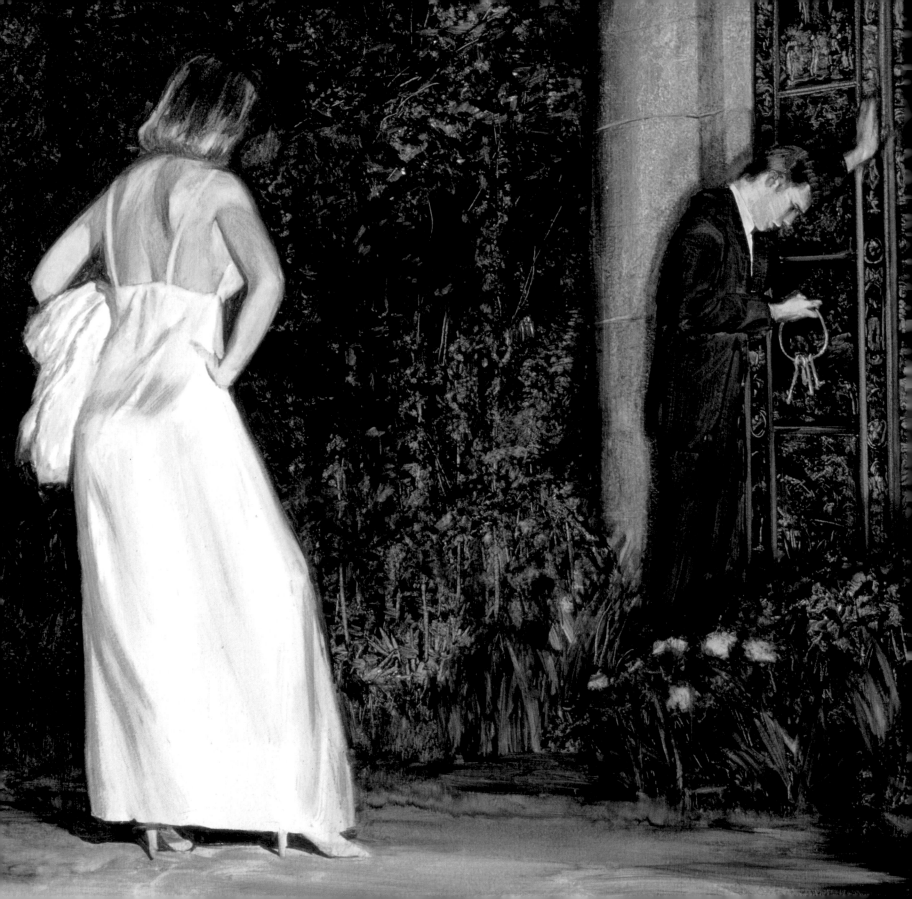

CAPRICCI AND SCHERZI

A PICTURE BEGINS WITH THE DESIRE TO make one of a certain kind. The kind that especially interests me arises from characteristics shared among the scherzi and capricci of Giambattista Tiepolo, the *caprichos* of Francisco Goya, and the collage novels of Max Ernst.

Capriccio carries the connotation of fantastic or whimsical idea.

Scherzo, a classic movement type in music, generally playful, swift, and light in character, is nevertheless a versatile form, spanning the humorous and frivolous to the grotesque and horrendous.

Pictorially Tiepolo covered these poles deftly.

Goya expanded them into searing political satire and incursions into the realm of nightmare.

Ernst's collage novels extended these characteristics into the surreal with the added impact of the collusion between the handmade and the reproduced.

What is particularly attractive about the capricci or scherzi is that they offer a malleable form for open-ended lightness or depth of query without the burdens of absolute or monumental assertion.

WHEELS OF CONTENT

Underlying this group of drawings is a schematic notion of pictorial content based on the wheel. This metaphoric structure was chosen, not as an assertion of fact, but rather because I've found it useful in mak-

CATALOGUE NUMBER 7

The Key, 1984

(detail)

ing it possible to mix distinctly different levels of content: the conceptual, the figural, and the formal, much as one mixes red, yellow, and blue on a color wheel. This underlying schema is emblematized and literalized in three-dimensional form by (the collaborative piece) *Wheel*, which invites the viewer into the process of mixing subjects, verbs, and objects. The resulting combinations, whether selected deliberately or by chance, can be self-sufficient or function as supplementary or motivating narratives as they did for many of these drawings.

The drawings consist of three suites: Wheels, Frameworks, and Nocturnes. Each improvises on a different structure as a metaphor of representation.

The first suite of drawings (1–8) takes the wheel as its formal structure. Different motifs and dynamics are explored, such as elemental swirls, spoke-and-hub structures, oscillating lenses, inward spirals of tunnel and whirlpool. Each picture focuses on the circular mixing of content.

The second suite (9–17) is the Frameworks, exploring the idea of representational content as matters of framing: art production as framing, frames as transformational edges and lines, frameworks as sites of representation, frames as substitutes for subject matter.

The third suite (18–22), Nocturnes, represents representations as trajectories of light, mobile markings, temporal scripting, mobile projectiles. No longer are the representations fixed or discrete but are open to any conceivable dimensional warps or impacts.

WORK PROCESS

After a thumbnail sketch and choice of a basic metaphoric structure my work process begins with collage making. Different sources—pictures and texts from magazines, books, and newspapers, my own photographs and drawings—are reproduced on a copy machine, affording repeatable, expendable incarnations for synthesizing into a collage. This is often followed by a graphite drawing from the collage, which in turn is used as though it were a veritable photographic source (drawings 1–2, 4).

The next step is the making of an unfixed toner copy of either the graphite drawing or the original collage. This becomes a "toner drawing" when completely reconstituted by hand. In contrast to the graphite drawing, which involves adding the darks, the process of toner drawing amounts to subtracting the lights by removing the toner. A wide variety of tools—from brushes, kneaded erasers, and crumpled paper to pinpoint and magnifying glass—is used to complete the toner drawing, which is then hand-fixed in its final form.

In a general way this picture-making process is a mode of inquiry carried out by open-ended interplay among many pictorial sources and signifiers. What should be apparent in this stepped process is that the handmade and the reproduced are set into a sort of dialectical dance. Beginning with alternating steps—manual to mechanical to manual to mechanical[1]—and ending up in an embrace so intimate that the two become virtually indistinguishable in the

toner drawing. With the awareness of new techno-
logical developments in computer-generated virtual
realities, it came to me as a bemused shock that
a somewhat anachronistic black-and-white copy
machine could produce a virtual space of its own by
allowing the hand to intervene in the reproductive
space between the machine's printer and heater. The
result is a strange wish fulfillment in which, unlike
the computer where the digitalizing interpretation
always intercedes between the hand and the image,
the copy machine allows the hand to imprint directly
on the reproductive surface and push around the
same toner granules that were just arrayed in the
mechanical imprint.

 This process brings questions concerning
original and copy, handmade and reproduced, to
bear directly on the formal content of each picture
and becomes a primary underlying theme of all
three suites.

1. Sidney Tillim, *Photography
Reproduction Production: The Work of Art
in the Age of Mechanical Reproduction*,
exh. cat. (Bennington, Vermont:
Suzanne Lemberg Usdan Gallery,
Bennington College, 1992), passim.

WHEELS

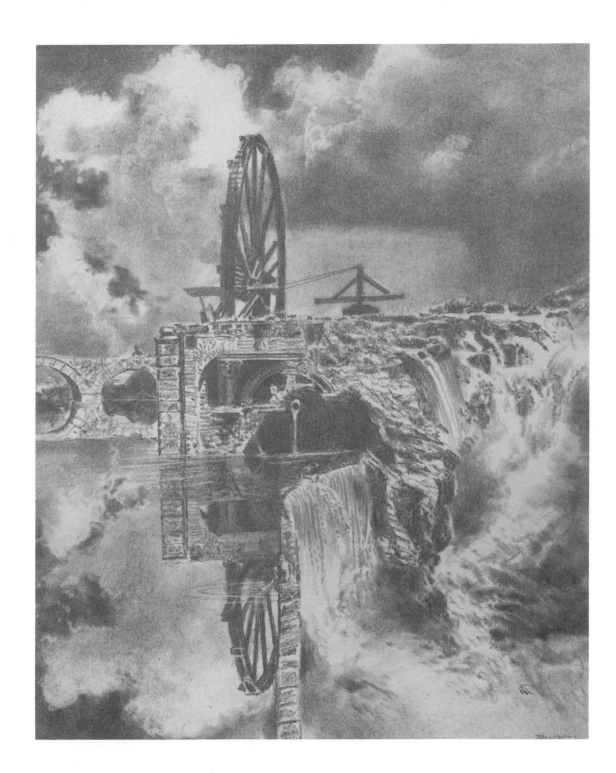

1. *Leonardo's Wheel*, 1992

 From the Wheels suite

 Graphite on paper

 9⅛ x 7¼ ins.

 (23.2 x 18.4 cm)

 Collection of the artist

2. *Rock*, 1992

From the Wheels suite

Graphite on paper

9⅛ x 7⅛ ins.

(23.2 x 18.1 cm)

Collection of the artist

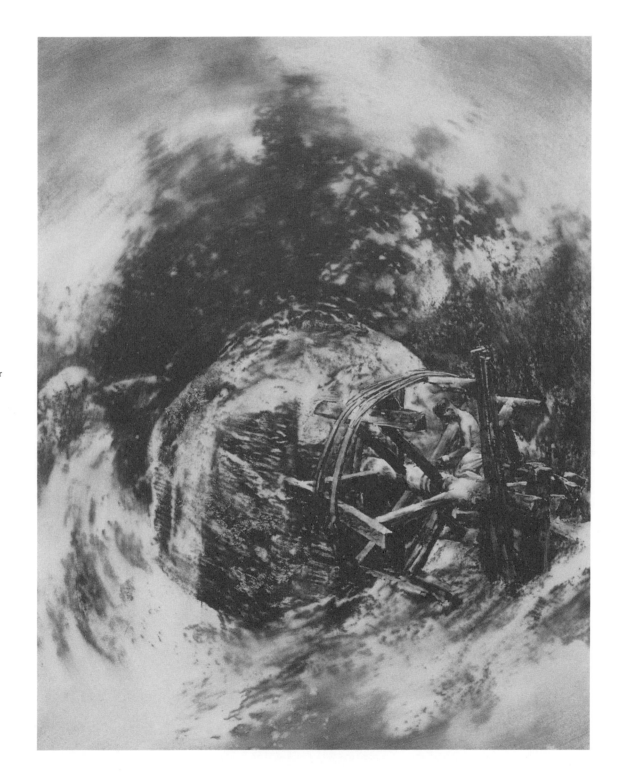

3. *Repairing the Wheel*, 1992

From the Wheels suite

Toner and graphite on paper

9 x 7 ins.

(22.9 x 17.8 cm)

Collection of the artist

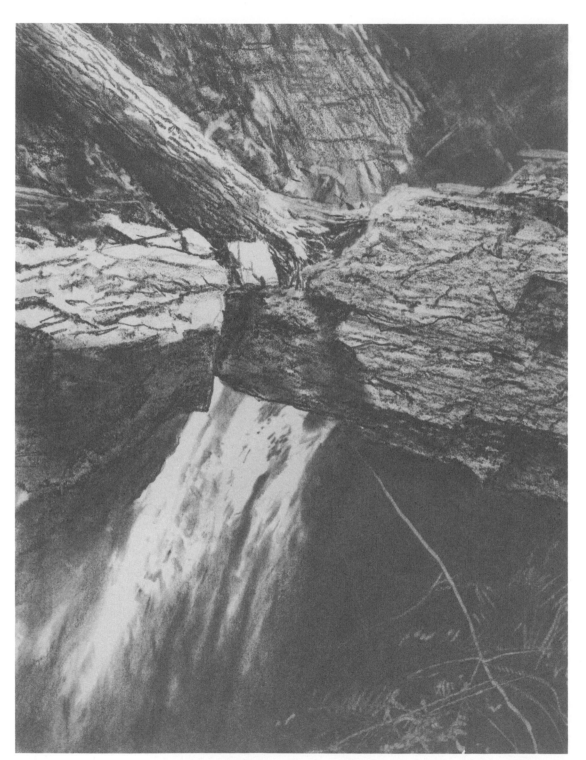

4. *Hub*, 1992

From the Wheels suite

Graphite on paper

9¼ x 7 ins.

(23.5 x 17.8 cm)

Collection of the artist

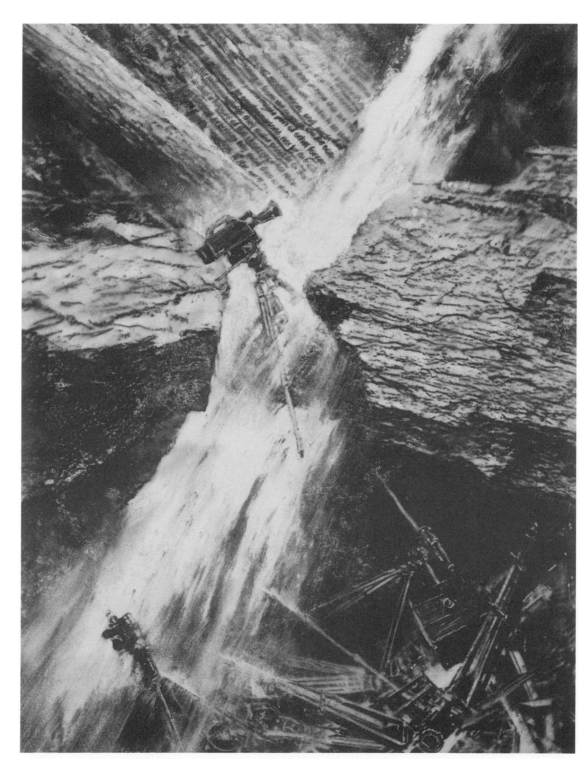

5. *Vigilant Machinery Caught in Discursive Formation*, 1992

From the Wheels suite

Toner on paper

9⅛ x 7⅛ ins.

(23.2 x 18.1 cm)

Collection of the artist

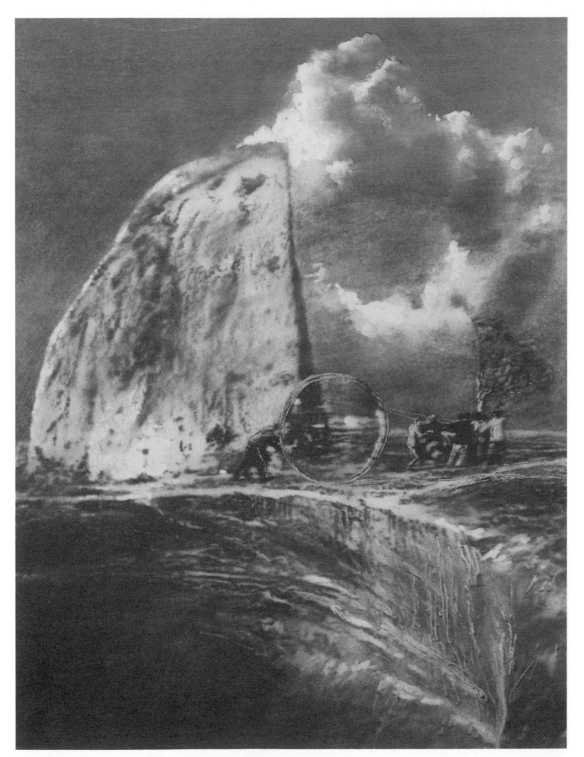

6. *Arch Empiricists Searching for a Moral*
Starting Point, 1992
 From the Wheels suite
 Toner on paper
 9¼ x 6⅛ ins.
 (23.5 x 15.6 cm)
 Collection of the artist

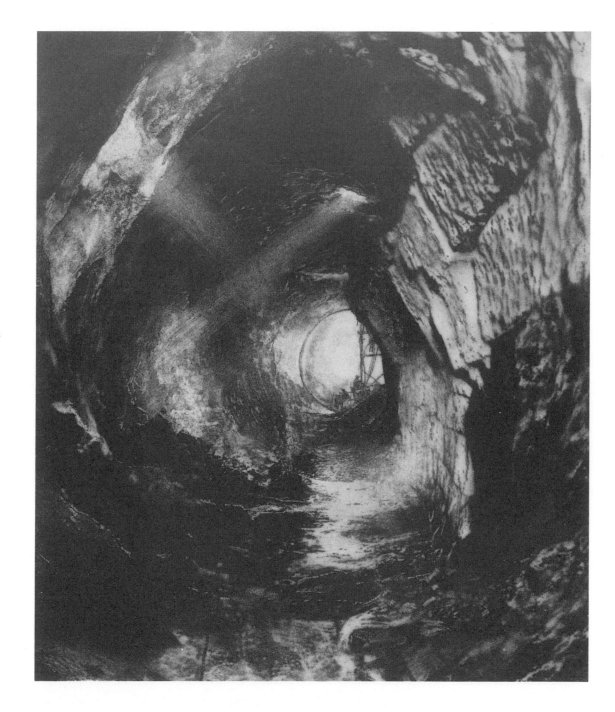

7. *Neoplatonists Installing the Lens*, 1992

From the Wheels suite

Toner on paper

8¼ x 7⅛ ins.

(21 x 18.1 cm)

Collection of the artist

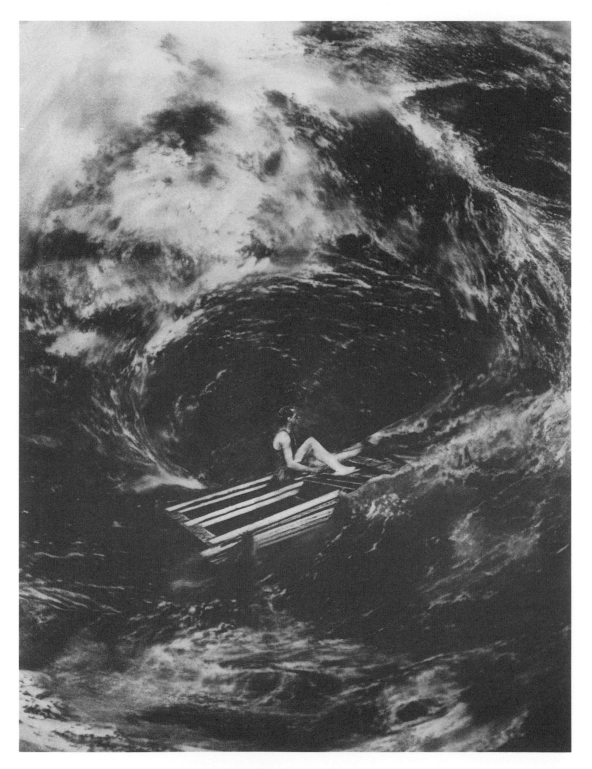

8. *Joseph Cornell at Westhampton*, 1992

From the Wheels suite

Toner on paper

9⅜ x 7⅛ ins.

(23.8 x 18.1 cm)

Collection of the artist

FRAMEWORKS

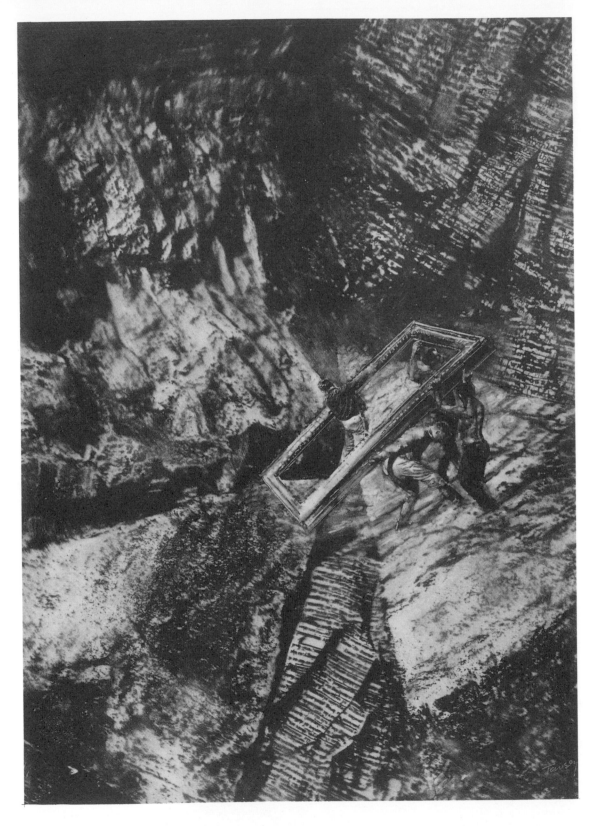

9. *Endgame Strategists Repositioning the Frame*, 1992

From the Frameworks suite

Toner on paper

9¼ x 6¾ ins.

(23.5 x 17.1 cm)

Collection of the artist

10. *The Bricoleur Redeploying the*

Framework, 1992

From the Frameworks suite

Toner on paper

9¾ x 6¾ ins.

(24.8 x 17.1 cm)

Collection of the artist

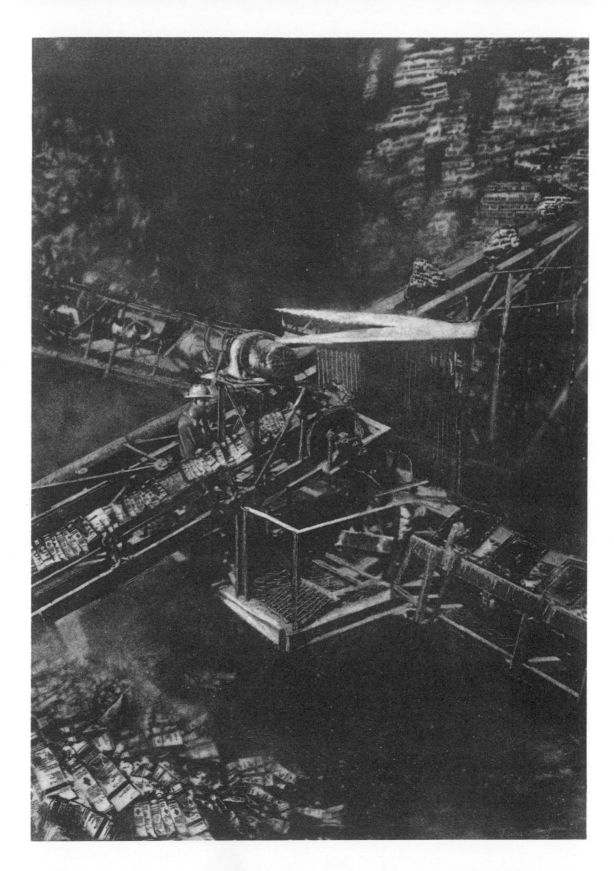

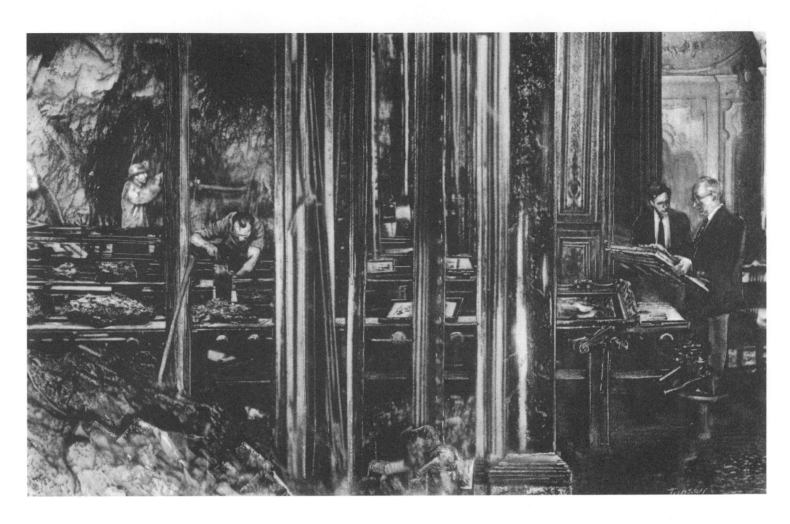

11. *The Raw and the Framed*, 1992

From the Frameworks suite

Toner and graphite on paper

6 x 10 ins.

(15.2 x 25.4 cm)

Collection of the artist

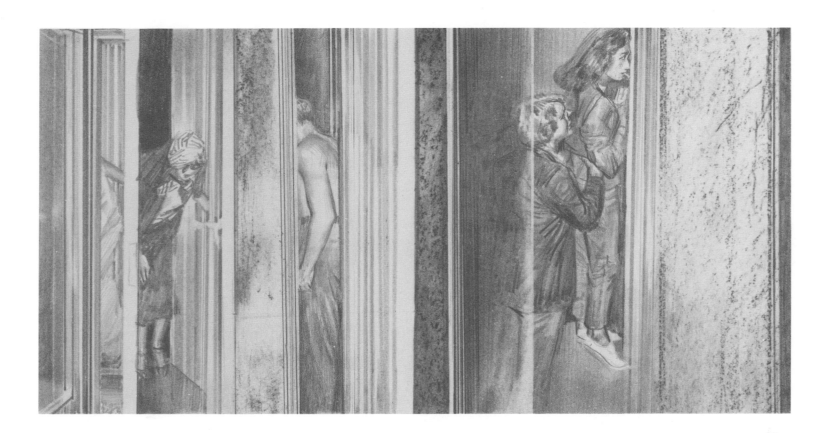

12. *Search for the MacGuffin*, 1992

 From the Frameworks suite

 Graphite on paper

 5¼ x 10¼ ins.

 (13.3 x 26 cm)

 Collection of the artist

13. *Church's Niagara*, 1992

From the Frameworks suite

Graphite on paper

5¼ x 8¾ ins.

(13.3 x 22.2 cm)

Collection of the artist

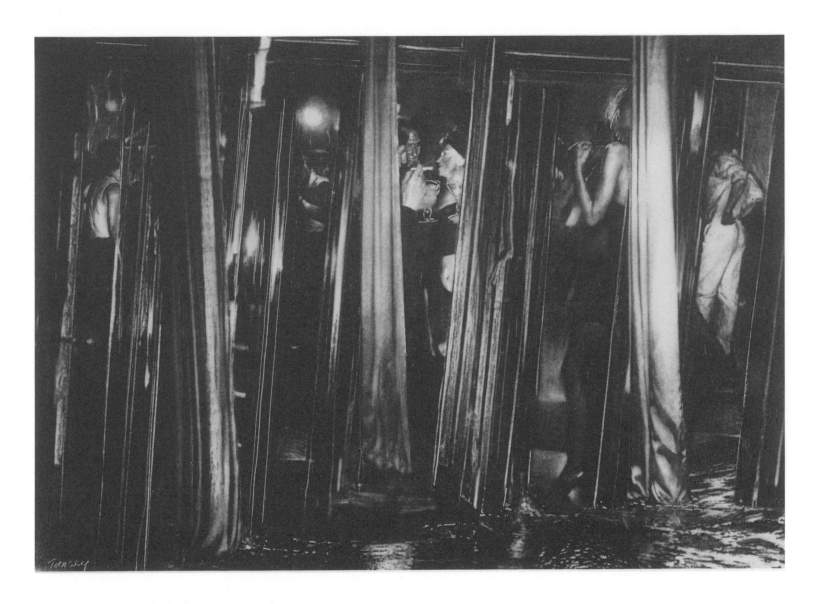

14. *Victorious Ahistorians Celebrating the*

 End of History, 1992

 From the Frameworks suite

 Toner on paper

 6¾ x 9½ ins.

 (17.1 x 24.1 cm)

 Collection of the artist

15. *Transition Team*, 1992

From the Frameworks suite

Toner on paper

8¼ x 7 ins.

(21 x 17.8 cm)

Collection of the artist

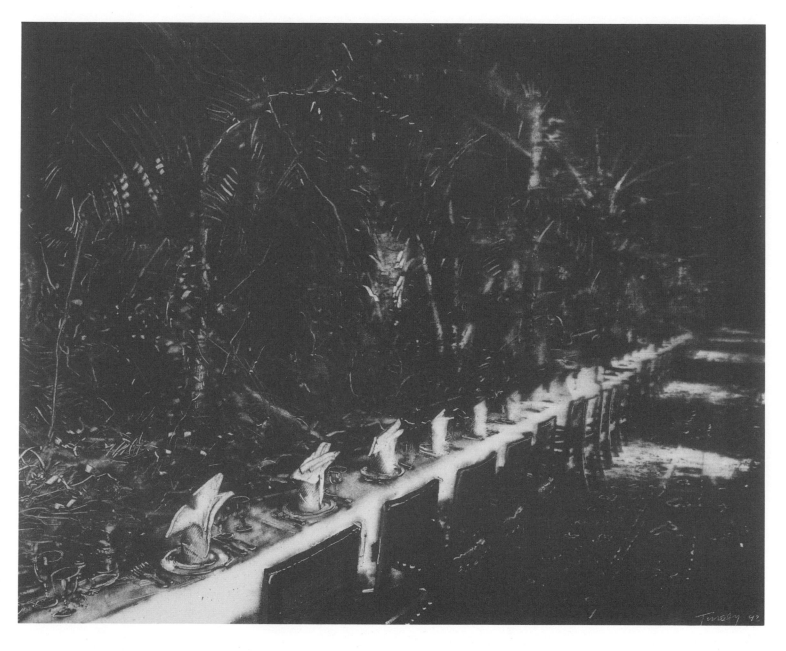

16. *Continental Divide*, 1992

 From the Frameworks suite

 Toner on paper

 7 x 8¾ ins.

 (17.8 x 22.2 cm)

 Collection of the artist

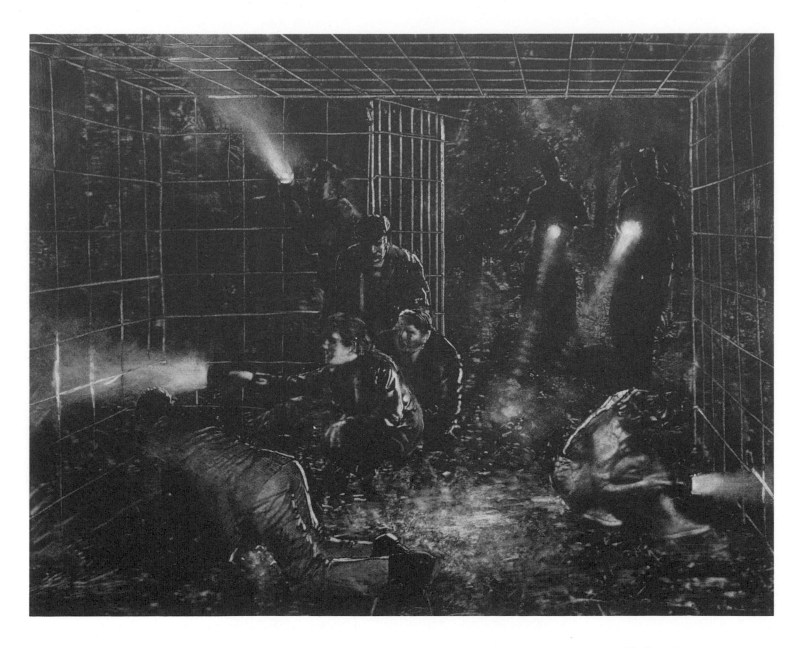

17. *The Empty Cage*, 1992

From the Frameworks suite

Toner on paper

6¾ x 8¾ ins.

(17.1 x 22.2 cm)

Collection of the artist

NOCTURNES

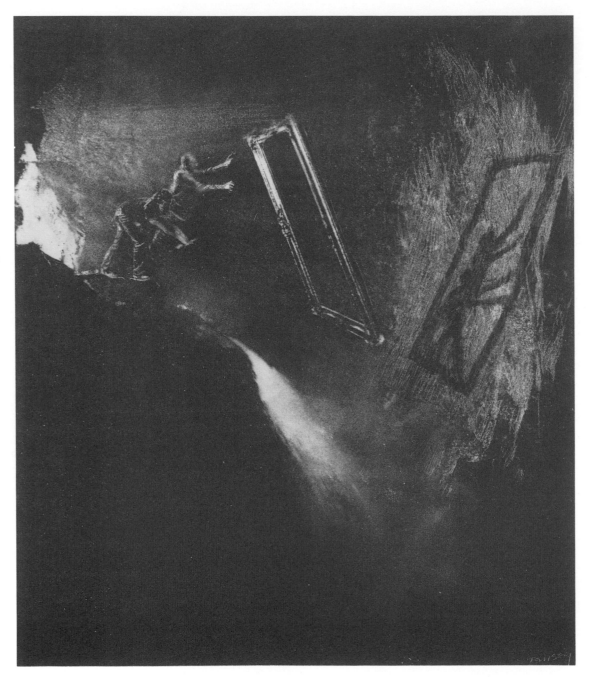

18. *Literalists Discarding the Frame*, 1992

From the Nocturnes suite

Toner on paper

8 x 7 ins.

(20.3 x 17.8 cm)

Collection of the artist

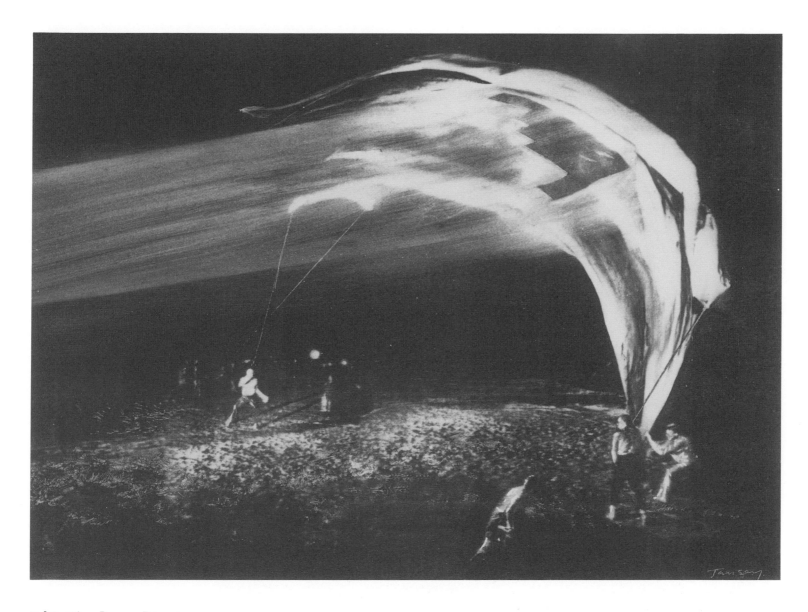

19. *Intercepting a Dangerous Representa-*

tion, 1992

 From the Nocturnes suite

 Toner on paper

 7⅛ x 10 ins.

 (18.1 x 25.4 cm)

 Collection of the artist

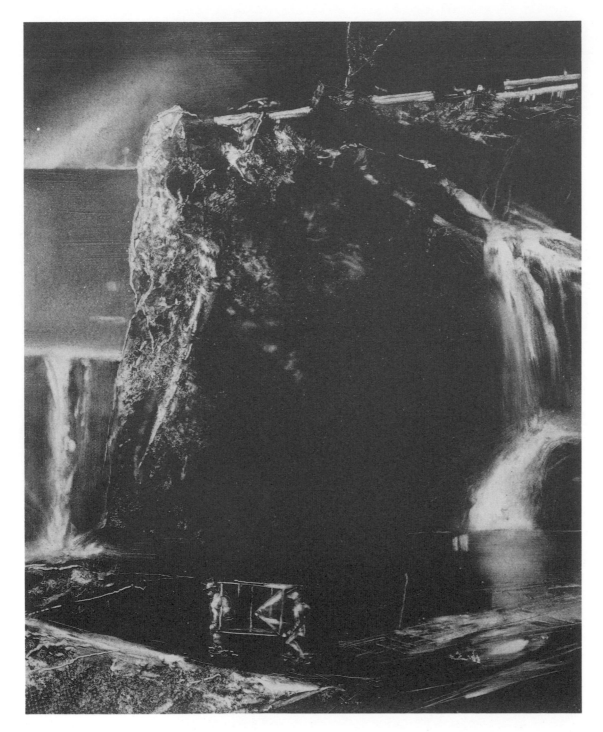

20. *Search for the Subject*, 1992
From the Nocturnes suite
Toner on paper
8⅝ x 7 ins.
(21.9 x 17.8 cm)
Collection of the artist

21. *Working against Time*, 1992

 From the Nocturnes suite

 Toner on paper

 9¼ x 7⅜ ins.

 (23.5 x 19.4 cm)

 Collection of the artist

22. *Nocturnal Niagara*, 1992

From the Nocturnes suite

Toner on paper

7 x 10 ins.

(17.8 x 25.4 cm)

Collection of the artist

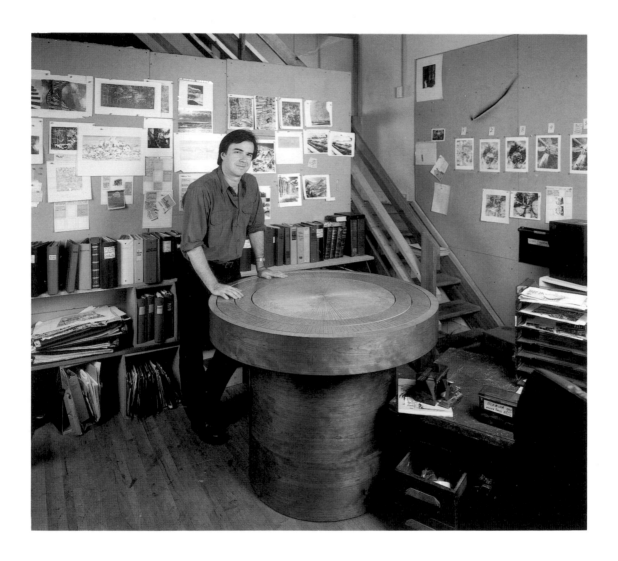

Mark Tansey's studio/archive,
Warren Street, New York,
1992.

born 1949, San Jose, California

lives in New York City

EXHIBITION HISTORY

1982

Grace Borgenicht Gallery, New York City. *Mark Tansey: Paintings*. October 16–November 18. Exh. cat., essay by Peter Frank.

1984

Grace Borgenicht Gallery, New York City. *Mark Tansey: Paintings*. March 2–28.

John Berggruen Gallery, San Francisco. *Mark Tansey: Recent Paintings and Drawings*. May 2–June 2.

Contemporary Arts Museum, Houston. *Mark Tansey: Paintings*. December 8–February 3, 1985.

1986

Curt Marcus Gallery, New York City. *Mark Tansey*. April 10–May 10.

1987

Curt Marcus Gallery, New York City. *Mark Tansey*. October 14–November 14.

1990

Curt Marcus Gallery, New York City. *Mark Tansey*. March 8–31.

Kunsthalle Basel. *Mark Tansey*. April 29–May 30. Exh. cat., essays by Günter Metken and Thomas Kellein.

Seattle Art Museum. *Mark Tansey: Art and Source.* Itinerary: Montreal Museum of Fine Arts, July 13–September 16; The Saint Louis Art Museum, October 3–November 11; Walker Art Center, Minneapolis, December 2–February 3, 1991; Seattle Art Museum, February 21–April 14, 1991; The Albert and Vera List Visual Arts Center, Massachusetts Institute of Technology, Cambridge, May 4–June 30, 1991; Modern Art Museum of Fort Worth, July 21–September 22, 1991. Exh. cat. by Patterson Sims.

Curt Marcus Gallery, New York City. *Mark Tansey: Drawings.* November 29–December 22.

1992

Curt Marcus Gallery, New York City. *Mark Tansey.* May 2–30.

GROUP EXHIBITIONS

1978

Fifth Street Gallery, New York City. *Artists of P.S. 122.*

1980

P.S. 122, New York City. *Open Studio Exhibition.* November 1–2.

The Drawing Center, New York City. *Selections 12.* November 12–January 10, 1981.

1981

Grace Borgenicht Gallery, New York City. *Episodes.* June 9–July 3. Exh. cat. by Carter Ratcliff.

The New Museum, New York City. *Not Just for Laughs: The Art of Subversion.* November 21–January 21, 1982. Exh. cat. by Marcia Tucker.

1982

Josef Gallery, New York City. *Narrative Settings.*

The Drawing Center, New York City. *New Drawing in America.* January 13–February 27.

Summit Art Center, New Jersey. *Drawing/New Directions.* March 7–April 8.

Indianapolis Museum of Art. *Painting and Sculpture Today, 1982*. July 6–August 15. Exh. cat., essay by Helen Ferrulli.

1983

Carol Taylor Fine Art, Dallas. *New Work/New York*.

Thorpe Intermedia Gallery, Sparkill, New York. *Humor and Play in Art, for the Fun of It*. January 23–March 13.

Whitney Museum of American Art, New York City. *1983 Biennial Exhibition*. March 24–May 22. Exh. cat.

The Chrysler Museum, Norfolk, Virginia. *Reallegory*. March 31–May 22. Exh. cat.

P.S. 1, Long Island City, New York. *Multiple Choice*. April 10–June 5.

The Queens Museum, New York City. *Twentieth-Century Art from the Metropolitan Museum of Art: Selected Recent Acquisitions*. July 16–October 16. Exh. bro.

The New Museum of Contemporary Art, New York City. *Language, Drama, Source & Vision*. October 8–November 27. Exh. bro. by Marcia Tucker. Curated by Lynn Gumpert, Ned Rifkin, and Marcia Tucker.

1984

Institute of Contemporary Art, Boston. *Currents*. January 2–31.

Museum of Art, Fort Lauderdale, Florida. *Narrative Painting: Selected Recent Acquisitions from the Metropolitan Museum of Art*. February 9–26.

Tower Gallery, New York City. *Body Politic*. April–May.

The Museum of Modern Art, New York City. *An International Survey of Recent Painting and Sculpture*. May 17–August 7. Exh. cat. by Kynaston McShine.

Independent Curators, Inc. *Drawing: After Photography*. Itinerary: Allen Memorial Art Museum, Oberlin College, Ohio, August 28–October 14; Mitchell Museum, Mount Vernon, Illinois, December 1–January 2, 1985; Aspen Center for the Visual Arts, Colorado, May 25–July 7, 1985; Leigh Yawkey Woodson Art Museum, Wausau, Wisconsin, July 25–September 1, 1985; Newport Harbor Art Museum, Newport Beach, California, October 17–December 8, 1985. Exh. cat. by William Olander and Andy Grundberg.

Museo Rufino Tamayo, Mexico City. *Nueva pintura narrativa* [New narrative painting]. November 5–December.

The Museum of Contemporary Art, Los Angeles. *Automobile and Culture*. July 24, 1984–January 6, 1985. Exh. cat. by Gerald Silk et al.

1985

Holman Hall Art Gallery, Trenton State College, New Jersey. *Contemporary Issues II*. January 30–February 27.

Lorence Monk Gallery, New York City. *Real Surreal*. May 4–25.

The Berkshire Museum, Pittsfield, Massachusetts. *Cultural Commentary*. November 9–January 5, 1986.

1986

Tsuromoto Room, Tokyo. *Correspondences: New York Art Now*. Exh. cat. by Nicolas Mouferrage.

Colorado Springs Fine Arts Center, Colorado. *The Figure in Twentieth-Century Art*. February 8–March 30. Exh. cat. by William S. Lieberman and Lowery Stokes Sims.

Whitney Museum of American Art at Equitable Center, New York City. *Figure as Subject: The Last Decade*. February 13–June 4. Exh. cat. by Patterson Sims.

Curt Marcus Gallery, New York City. *Inaugural Exhibition*. March 15–April 10.

CDS Gallery, New York City. *Artists Choose Artists IV*. April 3–May 3. Exh. cat. by Max Kozloff.

One Penn Plaza, New York City. *Short Stories*. June 1–September 5.

Venice Biennale. *Aperto 86*. June 29–September 28. Exh. cat.

City Gallery, New York City. *Cinemaobject*. September 9–October 11.

San Francisco Museum of Modern Art. *Second Sight: Biennial IV*. September 21–November 16. Exh. cat. by Graham W. J. Beal.

Neuberger Museum at the State University of New York, Purchase. *The Window in Twentieth-Century Art*. September 21–January 18, 1987. Itinerary: Contemporary Arts Museum, Houston, April 25–June 28, 1987. Exh. cat. by Suzanne Delahanty and Shirley Nielsen Blum.

Sherry French Gallery, New York City. *Telling Art*. November 5–December 6.

Lorence Monk Gallery, New York City. *The Manor in the Landscape*. November 22–December 20.

1987

Barbara Toll Fine Arts, New York City. *Monsters: The Phenomena of Dispassion*. January 17–February 7.

Gallery 400, University of Illinois, Chicago. *Tragic and Timeless Today: Contemporary History Painting*. February 4–March 14. Exh. cat. by Laurel Bradley.

Whitney Museum of American Art, Fairfield County, Connecticut. *Contemporary Diptychs: Divided Visions*. March 20–May 27. Itinerary: Whitney Museum of American Art, Equitable Center, New York City, September 11–November 4. Exh. cat. by Roni Feinstein.

Los Angeles County Museum of Art. *Avant-Garde in the Eighties*. April 25–July 12. Exh. cat. by Howard N. Fox.

The Museum of Modern Art, Art Advisory Service Exhibition, exhibited at the American Express Company, New York City. *Utopian Visions*. April 25–July 31.

The Art Museum at Florida International University, Miami. *American Art Today: The Portrait*. May 8–June 3. Exh. cat.

Museum Fridericianum, Kassel, Germany. *Documenta 8*. June 12–September 20. Exh. cat.

Grey Art Gallery, New York University, New York City. *Morality Tales: History Painting in the 1980s*. September 14–October 24. Itinerary: Laguna Art Museum, Laguna Beach, California, November 14–December 27; The Berkshire Museum, Pittsfield, Massachusetts, January 17–March 6, 1988; The Goldie Paley Gallery at Moore College of Art, Philadelphia, November 11–December 17, 1988; Duke University Museum of Art, Durham, North Carolina, January 13–February 26, 1989; Sheldon Memorial Art Gallery, University of Nebraska, Lincoln, April 11–May 26, 1989. Exh. cat. by Thomas W. Sokolowski.

Curt Marcus Gallery and Kent Fine Art, New York City. *Fictions: A Selection of Pictures from the 18th, 19th, and 20th Centuries*. November 17–December 31. Exh. cat. by Douglas Blau.

1988

Holman Hall Art Gallery, Trenton State College, New Jersey. *Bleckner, Richter, Tansey: Works from the Collection of Robert M. Kaye*. March 2–25. Exh. cat.

The Queens Museum, New York City. *Classical Myth and Imagery in Contemporary Art*. April 15–June 12. Exh. cat. by Barbara C. Matilsky.

Marlborough Gallery, New York City. *Visions/Revisions: Contemporary Representations*. April 29–May 28. Exh. cat. by Sam Hunter.

Long Beach Museum of Art, Long Beach, California. *Selections from the Berkus Collection*. May 1–June 5. Exh. cat. by Josine Ianco-Starrels.

The Art Museum at Florida International University, Miami. *American Art Today: Narrative Painting*. May 6–June 4. Exh. cat.

1989

P.P.O.W., New York City. *Broken Landscape, Discarded Object*. January 10–February 8. Curated by Christopher Sweet.

Frankfurter Kunstverein, Frankfurt. *Prospect 89*. March 21–May 21. Exh. cat.

Modern Art Museum of Fort Worth. *10 + 10: Contemporary Soviet and American Painters.* May 14–August 6. Itinerary: San Francisco Museum of Modern Art, September 6–November 4; Albright-Knox Art Gallery, Buffalo, November 18–January 7, 1990; Milwaukee Art Museum, February 2–March 25, 1990; Corcoran Gallery of Art, Washington, D.C., April 21–June 24, 1990; Artists' Union Hall of the Tretyakov Gallery, Moscow, July 18–August 15, 1990; State Picture Gallery of Georgia, Tbilisi, September 5–October 3, 1990; Central Exhibition Hall, Leningrad, October 24–November 21, 1990. Exh. cat., essays by John E. Bowlt and Victor Misiano.

Thomas Solomon's Garage, Los Angeles. *The Observatory.* June 3–18. Exh. cat. by Douglas Blau.

National Museum of Modern Art, Tokyo, and National Museum of Modern Art, Kyoto. *Color and/or Monochrome.* September 30–November 26 (Tokyo); January 5–February 12, 1990 (Kyoto). Exh. cat. by Masanori Ichikawa and Tohru Matsumoto.

Whitney Museum of American Art, New York City. *Image World: Art and Media Culture.* November 8, 1989–February 18, 1990. Exh. cat. by Marvin Heiferman and Lisa Phillips with John G. Hanhardt.

Art Gallery of Western Australia, Perth. *Romance and Irony in Recent American Art.* Itinerary: National Art Gallery, Wellington, New Zealand, November 10–January 14, 1990; Art Gallery of Western Australia, Perth, February 21–April 16, 1990; Auckland City Art Gallery, New Zealand, June 28–August 19, 1990; Tampa Museum of Art, November 18–December 30, 1990; Parrish Art Museum, Southhampton, New York, June 16–August 11, 1991. Exh. cat. by Louis Grachos, John Stringer, and Richard Martin.

Shea and Becker, New York City. *In the Realm of the Plausible.* January 10–February 3. Curated by John Yau.

Edward Thorp Gallery, New York City. *Storyline.* February 3–March 3.

Virginia Museum of Fine Arts, Richmond. *Harmony and Discord: American Landscape Painting Today.* August 7–September 30.

Galerie Thaddaeus Ropac, Paris. *Vertigo.* October 26–November 26. Exh. cat. by Christian Leigh.

Whitney Museum of American Art, Downtown Branch, New York City. *The Charade of Mastery: Deciphering Modernism in Contemporary Art.* October 31–January 11, 1991. Exh. cat. by Sarah Morris, Richard Quinn, and Julia Reschop.

Lorence Monk Gallery, New York City. *Dead Heroes, Disfigured Love.* February 2–24. Curated by Christopher Sweet.

Whitney Museum of American Art, New York City. *1991 Biennial Exhibition.* April 19–June 30. Exh. cat.

Josh Baer Gallery, New York City. *The Library.* May 24–June 29. Exh. cat. by Douglas Blau.

James Howe Gallery, Kean College of New Jersey, Union. *The Word-Image in Contemporary Art.* February 20–March 19. Curated by Lewis Kachur.

Suzanne Lemberg Usdan Gallery, Bennington College, Vermont. *Photography Reproduction Production: The Work of Art in the Age of Mechanical Reproduction.* April 21–May 15. Exh. cat. by Sidney Tillim.

BIBLIOGRAPHY

1980

Larson, Kay. "Constructive Criticism." *Village Voice*, 29 October, 85.

Zimmer, William. "Schooling Around (Cont'd)." *Soho News*, 29 October, 62, 64.

1981

Zimmer, William. "Paper Chase." *Soho News*, 7 January, 48.

Levin, Kim. "Voice Choice." *Village Voice*, 24 June, 64.

Zimmer, William. "Flock of the New." *Soho News*, 24 June, 47.

Raynor, Vivien. "Group Show by Seven at Borgenicht Gallery." *New York Times*, 26 June, C26.

Perreault, John. "The Joke's on View." *Soho News*, 8 December, 49.

Schjeldahl, Peter. "But Seriously, Folks" *Village Voice*, 9 December, 102, 111.

1982

Earley, Michael. "Riot Acts." *Live 6/7* 1: 32–35.

Friedman, K. S., and Peter Frank. "Art Futures." *Art Economist* 2, no. 4 (28 February): 6–9.

Caldwell, John. "Contemporary Artists in Summit Exhibit." *New York Times*, 28 March, sect. 11, p. 32.

Raynor, Vivien. "Mark Tansey in First Solo Show." *New York Times*, 5 November, C19.

Smith, Roberta. "Four Formulas in Flux." *Village Voice*, 9 November, 78.

Larson, Kay. "Ways with Wit." *New York*, 15 November, 98, 101.

1983

Friedman, Jon R. "Mark Tansey." *Arts Magazine* 57, no. 5 (January): 10.

[Phillips, Deborah C.] "Mark Tansey." *ArtNews* 82, no. 1 (January): 144–45.

Zelevansky, Lynn. "Mark Tansey." *Flash Art*, no. 110 (January): 65.

Cohen, Ronny H. "Drawing Now in New York City: The New Pictorial Image of the Eighties." *Drawing* 4, no. 5 (January–February): 97–101.

Armstrong, Richard. "Mark Tansey." *Artforum* 21, no. 6 (February): 75–76.

Owens, Craig. "Mark Tansey." *Art in America* 71, no. 2 (February): 137–38.

Phillips, Deborah C. "Mark Tansey." *ArtNews* 82, no. 2 (February): 144.

Russell, John. "Why the Latest Whitney Biennial Is More Satisfying." *New York Times*, 25 March, C1.

Annas, Teresa. "Allegory More than You See." *Virginia-Pilot and Ledger-Star*, 10 April, G1, G10.

Ashbery, John. "Biennials Bloom in the Spring." *Newsweek*, 18 April, 93–94.

Brenson, Michael. "Artists Grapple with New Realities." *New York Times*, 15 May, sect. 2, p. 1.

Bell, Jane. "Biennial Directions: The 1983 Whitney Biennial." *ArtNews* 82, no. 6 (summer): 76–79.

Russell, John. "Midsummer Stirrings at the Museum of Modern Art." *New York Times*, 10 July, sect. 2, p. 27.

Linker, Kate. "Multiple Choice." *Artforum* 22, no. 1 (September): 77–78.

Russell, John. "New New Museum." *New York Times*, 7 October, C29.

1984

Freeman, Phyllis, et al., eds. *New Art*. New York: Harry N. Abrams, 1984.

Russell, John. "Met Honors Chase, an American Legend." *New York Times*, 9 March, C22.

Levin, Kim. "Revue Review." *Village Voice*, 27 March, 96.

Wolff, Theodore F. "How New York Artists Speak to Each Other—On Canvas." *Christian Science Monitor*, 28 April, 19.

Regan, Kate. "The Battlefields of Art—and Everyday Illusions." *San Francisco Chronicle*, 5 May, "Datebook" 37.

Larson, Kay. "Tips of the Icebergs." *New York*, 28 May, 94–95.

1986

Saltz, Jerry, Roberta Smith, and Peter Halley. *Beyond Boundaries: New York's New Art.* New York: Alfred van der Marck.

Martin, Richard. " 'Rust Is What Our Metal Substitutes for Tears': The New Paintings of Mark Tansey." *Arts Magazine* 60, no. 8 (April): 18–19.

Loughery, John. "Figure as Subject." *Arts Magazine* 60, no. 9 (May): 122–23.

Russell, John. "Mark Tansey." *New York Times*, 2 May, C28.

Indiana, Gary. "Apotheosis of the Non-moment." *Village Voice*, 6 May, 61.

Cameron, Dan. "Report from the Front." *Arts Magazine* 60, no. 10 (summer): 86–93.

Cone, Michèle. "Mark Tansey." *Flash Art*, no. 129 (summer): 69.

Kuspit, Donald. "Mark Tansey." *Artforum* 25, no. 1 (September): 132–33.

Green, Blake. "A Curator's New Culture." *San Francisco Chronicle*, 20 September, 11.

Heartney, Eleanor. "Mark Tansey." *ArtNews* 85, no. 8 (October): 134.

Smith, Roberta. "The Manor in the Landscape." *New York Times*, 12 December, C26.

Indiana, Gary. "Landscape Today." *Village Voice*, 15 December, 91–92.

1987

Blau, Douglas. "Where the Telephone Never Rings: Tansey's *Conversation*, 1986." *Parkett*, no. 13: 34–39.

McCormick, Carlo. "Fracts of Life." *Artforum* 25, no. 5 (January): 91–95.

Russell, John. "Monsters: The Phenomena of Dispassion." *New York Times*, 30 January, C22.

Johnson, Allen. "The Death of Ethnography." *Sciences* 27, no. 2 (March–April): 24–30.

Joselit, David. "Milani, Innerst, Tansey." *Flash Art*, no. 134 (May): 100–101.

———. "Wrinkles in Time." *Art in America* 75, no. 7 (July): 106–11, 137.

Larson, Kay. "Shrinking History." *New York* 5 October, 101–3.

Martin, Richard. "Cézanne's Doubt and Mark Tansey's Certainty on Considering *Mont Sainte-Victoire*." *Arts Magazine* 62, no. 3 (November): 79–83.

———. "Morality Tales." *Arts Magazine* 62, no. 4 (December): 97.

1988

Rouhiainen, Anne. "Kadonnutta alkuperäisyttä etsimässä" [In search of lost originality]. *Taide* 29, no. 1: 18–21, 70–71. In Finnish.

Kandel, Susan, and Elizabeth Hayt-Atkins. "Mark Tansey." *ArtNews* 87, no. 1 (January): 152.

Holert, Tom. "Mark Tansey und seine Bilder"; "Tamed Reference: Mark Tansey and His Paintings." *Wolkenkratzer Art Journal* 1 (January–February): 44–51, 107–8.

Mahoney, Robert. "Fictions." *Arts Magazine* 62, no. 6 (February): 108–9.

Martin, Richard. "Fictions" and "Mark Tansey's *Triumph over Mastery*." *Arts Magazine* 62, no. 6 (February): 97 and 23–25.

Perl, Jed. "From September to December." *New Criterion* 6, no. 6 (February): 43–54.

Albig, Jörg-Uwe. "Ein Denker malt Kritik" [A philosopher paints critiques]. *Art: Das Kunstmagazin*, no. 4 (April): 36–54. In German.

Cooke, Lynne. "Fictions." *Artscribe*, no. 70 (summer): 84–85.

Joselit, David. "Mark Tansey." *Bijutsu Techo* 40 (October): 70–71. In Japanese.

Metken, Günter. "Attacken gegen die Avantgarde. Mark Tansey, ein Historienmaler der Postmoderne" [Attack against the avant-garde. Mark Tansey: A history painter of the post-modern]. *Frankfurter Allgemeine Zeitung*, 8 October, 27. In German.

1989

Hjort, Øystein. "Kunst, Kitsch, Überkitsch: Nogle af 80-ernes amerkanske Kunstnere" [Art, kitsch, hyperkitsch: Some American artists of the 1980s]. *Kritik* 88: 87–103. In Danish.

Brenson, Michael. "Straitened Landscapes of a Post-Modern Era." *New York Times*, 13 January, sect. 3, 32.

Pincus-Witten, Robert. "Entries: Concentrated Juice & Kitschy Kitschy Koons." *Arts Magazine* 63, no. 6 (February): 34–39.

Cantor, Judy. "La rueda de la fortuna/Wheel of Fortune." *Arena International Art* 3 (June): 68–75. In Spanish and English.

Knight, Christopher. "A Photographic Observatory." *Los Angeles Herald-Examiner*, 16 June, 34.

Holz, Hans Heinz. "Andy Warhol: Vom Mechanismus des Erfolgs" [Andy Warhol: About the mechanism of success]. *Artis* 41, nos. 7–8 (July–August): 30–35. In German.

Hughes, Robert. "Mucking with Media." *Time*, 25 December, 93.

1990

Grundberg, Andy. *Crisis of the Real: Writings on Photography, 1974–1989*. New York: Aperture Foundation.

"Rückzugsgefechte der Moderne" [Retrenching of the modern]. *Dumont's Chronik der Kunst im 20. Jahrhundert*, 834. In German.

Wolf, Bryan. "What the Cow Saw, or, Nineteenth-Century Art and the Innocent Eye." *Antiques* 137, no. 1 (January): 276–85.

Van Niekerk, Mike. "Gallery Helmann's Major Coup." *Western Australian*, 13 January, "Art Weekend," 38.

"Double Take Tansey." *American Way*, 15 February, 72–77.

Smith, Roberta. "Storyline." *New York Times*, 16 February, C30.

Levin, Kim. "Studio Visits." *Mirabella*, March, 58–59.

Bromfield, David. "Exhibiting a Belief in Making Paintings." *Western Australian*, 3 March, 64.

Kramer, Hilton. "Richter Exhibit at N.Y.U. Gallery: Cynically Versatile and Fradulent." *New York Observer*, 16 April, 1, 27.

Gassert, Sigmar. "Globale Ansprüche der Kunst" [Global demands of art]. *Basler Agenda*, 26 April, 77. In German.

Müller, Hans-Joachim. "Geheimnis der Sphinx" [Secret of the Sphinx]. *Basler Zeitung*, 30 April, 49. In German.

Oe, K. "Grenzenlose Malerei" [Painting without limits]. *Schweizer Illustrierte*, 30 April, 110. In German.

Murray, Kevin. "Romance and Irony." *Art & Text*, no. 36 (May): 129–30.

"Unseren Blick für die weite Welt der Kultur öffnen" [Our view of the world at large]. *Nordschweiz, Basler Volksblatt* 5 May, 33. In German.

"Mark Tanseys unrealistischer Realismus" [Mark Tansey's unrealistic realism]. *Nordschweiz/Basler Volksblatt* 31 May, 33. In German.

Mahoney, Robert. "New York in Review." *Arts Magazine* 64, no. 10 (summer): 92–94.

Miller, John. "Mark Tansey." *Artforum* 28, no. 10 (summer): 166.

Danto, Arthur C. "The State of the Art World: The Nineties Begin." *Nation*, 9 July, 65–68.

Grundberg, Andy. "Attacking Not Only Masters but Mastery as Well." *New York Times*, 23 November, C29.

Marger, Mary Ann. "Romantic Art Tinged with Irony." *Saint Petersburg Times*, 30 November, 27.

Abbe, Mary. "Tansey's Works Almost Too Clever." [Minneapolis] *Star Tribune*, 20 December, E1.

1991

Exhibition review (Seattle Art Museum). *Seattle Weekly*, 20 February, 11.

Hackett, Regina. "Art-smart Tansey Is a Trickster Who Delivers the Goods." *Seattle Post-Intelligencer*, 21 February, C6.

Mathieson, Karen. "The Color of Memory." *Seattle Times*, 21 February, D5.

Nesbitt, Lois E. "Mark Tansey." *Artforum* 29, no. 7 (March), 129.

Smith, Roberta. "A Selection of Work from the 80's, at the Whitney." *New York Times*, 8 March, C26.

Patin, Thomas. "Up and Down the Theory Ladder: Mark Tansey at the Seattle Art Museum." *Artweek* 22, no. 10 (14 March), 20.

Knight, Christopher. "Four Floors of Evolution." *Los Angeles Times,* 28 April, "Calendar" 3, 88.

Larson, Kay. "A Shock to the System." *New York*, 29 April, 86–87.

Temin, Christine. "Mark Tansey—Recycled Images Made Fresh." *Boston Globe*, 22 May, 78.

Smith, Roberta. "The Library." *New York Times*, 14 June, C24.

"The Library at Josh Baer Gallery." *New Yorker*, 17 June, 14.

Leigh, Christian. "The 1991 Whitney Biennial." *Flash Art* 24, no. 159 (summer): 161.

Metken, Günter. "Mark Tansey." *Flash Art* 24, no. 159 (summer): 162.

Lipson, Karin. "Modern Romantic Vision." [New York] *Newsday*, 21 June, pt. 2, p. 94.

Braff, Phyllis. "Exhibition Is Window on Society." *New York Times*, 28 July, 17.

Tanaka, Hiroko. "[Art in New York]." *Hi Fashion* (Tokyo), September, 164–65. In Japanese.

Danto, Arthur C. "L'Esperluète et le point d'exclamation: À propos de *High and Low* et d'*Art et Pub*" [The ampersand and the exclamation point: À propos of *High and Low* and *Art et Pub*]. *Cahiers du Musée national d'art moderne* 37 (autumn): 97–110. In French.

1992

Danto, Arthur C. *Mark Tansey: Visions and Revisions.* New York: Harry N. Abrams.

Holm, Michael Juul. "Maleren Mark Tansey" [Mark Tansey the painter]. *Kritik* 5, no. 98: 65–68. In Danish and English.

Arndal, Lars. "Velrettede hug i debatten" [Well-directed cuts and thrusts in the debate]. *Kristeligt Dagblad*, 24 February, 32. In Danish.

Hirschorn, Michael. "Mark Tansey's Lit-Crit Wit." *Esquire*, May, 28.

Stevens, Mark. "Magritte Expectations." *Vanity Fair*, May, 106–8.

Danto, Arthur C. "Trompe l'oeil." *Nation*, 4 May, 603–8.

Levin, Kim. "Mark Tansey." *Village Voice*, 19 May, 76.

Cotter, Holland. "Mark Tansey." *New York Times*, 29 May, C24.

Anfam, David. "Winters, Wegman, de Kooning, and Tansey." *Burlington Magazine* 134, no. 1072 (July): 466–67.

Weirup, Torben. "Verden og billedit vendt på hovedet" [The world and the picture turned upside down]. *Berlingske Tidende*, 3 July, sect. 2, 1. In Danish.

Bass, Ruth. "Mark Tansey." *ArtNews* 91, no. 8 (October): 121.

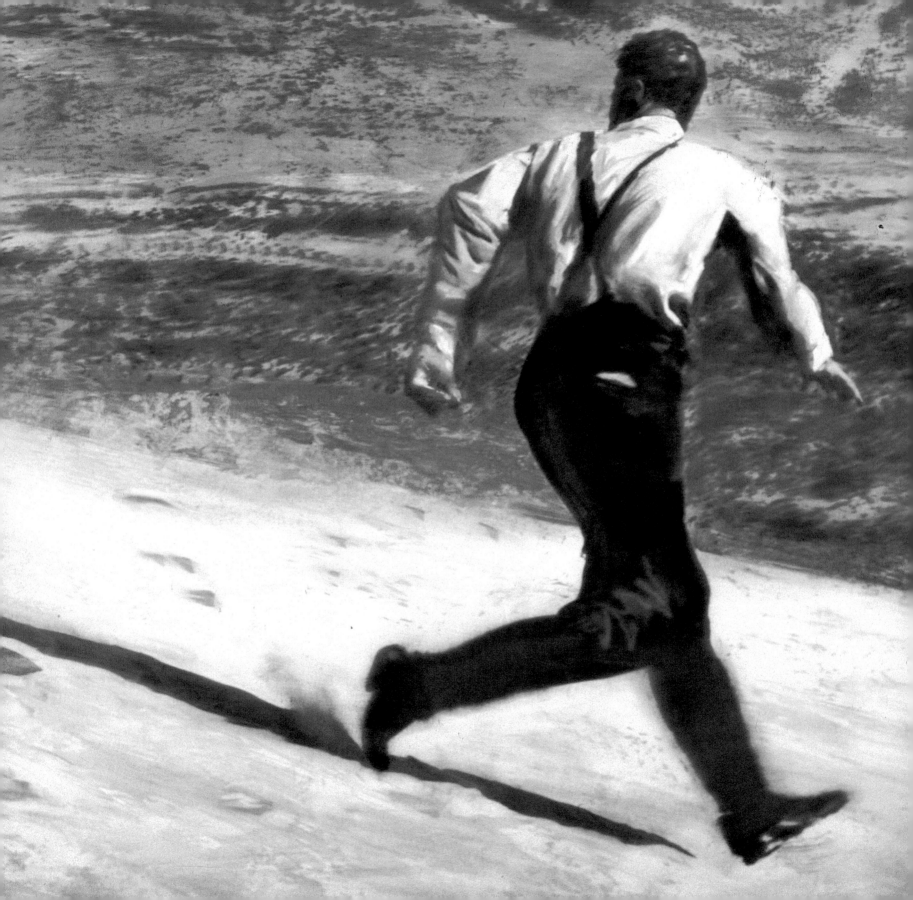

AFTERWORD

IN THIS FINAL DECADE OF THE TWENTIETH century artists are reflecting increasingly on the state of the visual arts and directions most worthy of pursuit. Mark Tansey is at the forefront of this campaign. Though labeled variously as a history painter, narrative artist, and postmodernist, he creates paintings that defy each of these characterizations. They are complex vehicles for the contemplation of what we see and why we see it.

This volume documents an exhibition organized by the Los Angeles County Museum of Art which is intended to examine the meaning of Tansey's paintings. It is eloquently introduced by Alain Robbe-Grillet, the prolific French philosopher, filmmaker, and author. Because Robbe-Grillet was the protagonist

in Tansey's first painting devoted to speculations on meaning (cat. no. 3), it seemed appropriate to provide him the opportunity to offer his thoughts on Tansey's work. The resulting statement is a captivating reverie, conjuring up an imaginary Tansey tableau.

This book has also been enriched by the contribution of the artist. Following thematic discussions with Judi Freeman, the exhibition's curator, Tansey created twenty-two drawings expressly for this publication. These are arranged in three groups, mirroring the triad of metaphorical strands explored in the exhibition while following an order precisely plotted by the artist himself. In his accompanying statement Tansey has articulated his art-making process.

Ms. Freeman's conception of the exhibition and of this publication represents a reconsideration of how best to present the work of an established contemporary artist in the museum context.

We are delighted that the Mark Tansey exhibition will be presented not only at the Los Angeles County Museum of Art but also at the Milwaukee Art Museum, Modern Art Museum of Fort Worth, Museum of Fine Arts, Boston, and Montreal Museum of Fine Arts. It has been a pleasure to work with our colleagues Russell Bowman, Marla Price, Alan Shestack, and Pierre Théberge at their respective institutions.

Above all, we are indebted to the lenders to the exhibition. Mark Tansey's work has been in considerable demand for exhibitions worldwide in recent years, and we are appreciative that the owners of these paintings generously agreed to share them with the public.

Michael E. Shapiro
DIRECTOR
LOS ANGELES COUNTY MUSEUM OF ART

ACKNOWLEDGMENTS

MARK TANSEY'S PAINTINGS ARE INTRICATE. Trying to explicate them required retracing the artist's preparation. Reconstructing his complex thought processes is a laborious but rewarding exercise. What Mark cannot conjure instantly from memory resides in the voluminous and meticulously organized archive in his studio.

Working closely with Mark has been a challenging and enviable endeavor. He was generous and patient as I grappled with the content of his paintings. Never satisfied with simple responses, he returned to questions and issues that we both raised time and again, shedding light on numerous readings of his pictures. I am grateful to him for sharing his thoughts in the course of several extensive interviews and for

participating intellectually in every phase of the organization of this exhibition and publication.

His dealer, Curt Marcus, offered sage advice and welcome assistance at every turn. I also appreciate the considerable efforts of Carrie Kahn, Katherine Gass, and Helen Ratcliffe at the Curt Marcus Gallery.

Alain Robbe-Grillet's commentary on Mark's work, contributed to this volume despite his busy schedule, provides fresh insight into the artist's work.

I also benefited from the assistance of Thomas Ammann, Kay Bearman, Judith Calamandre, Charles Cowles, Shelley de Angelus, David and Susan Gersh, Romy Golan, Louis Grachos,

Joanne Heyler, Susan Kandel, Michael Kohn, Richard Martin, Inge-Vibeke Raaschou Nielsen, Thaddaeus Ropac, Cora Rosavear, Michel Rybalka, Patterson Sims, Thomas Solomon, Christopher Sweet, Ramon Tio Bellido, Jennifer Wells, and especially Douglas Blau with my research and writing as well as securing loans for the exhibition. Bruce White capably photographed works in Mark's studio.

The exhibition's lengthy itinerary was made possible thanks to the generosity of the lenders participating. I value the involvement of colleagues Russell Bowman and Dean Sobel at the Milwaukee Art Museum, Marla Price and Robert Bowen at the Modern Art Museum of Fort Worth, Trevor Fairbrother at the Museum of Fine Arts, Boston, and Pierre Théberge at the Montreal Museum of Fine Arts.

At the Los Angeles County Museum of Art former director Earl A. Powell III and senior curator of twentieth-century art Maurice Tuchman endorsed this exhibition from its inception. Director Michael E. Shapiro joined the museum during the project's final stage and enthusiastically supported its realization. Dedicated museum volunteer Lois Sein skillfully assisted me with every aspect of its coordination. Intern Wendy Weil provided bibliographic assistance. Elizabeth Algermissen and John Passi of the exhibitions department oversaw the budget and tour of the exhibition. Tom Jacobson, Talbot Welles, Lynn Terelle, Leo Tee, and Samantha Potter solicited and coordinated its funding. Registrar Renee Montgomery and associate registrar Tamra Yost supervised the packing, shipping, and transport of the works of art.

Arthur Owens, assistant director for operations, and Michael Tryon, senior art preparator, coordinated the exhibition's installation in Los Angeles. Mitch Tuchman, the museum's editor in chief, oversaw the conceptualization of this book and edited its text; head designer Sandy Bell helped to formulate the initial concept for the catalogue's design, and the book's designer Amy McFarland, imbued this volume with its distinctive style and character. Peter Brenner coordinated the photography used in this volume. I salute these colleagues, gratefully acknowledging their contributions and those of other dedicated members of the museum's staff.

No exhibition could be successfully realized without the contributions and enthusiasm of its lenders. I join with Mark Tansey in thanking them for allowing their works of art to be presented in this exhibition.

Judi Freeman

CATALOGUE OF THE EXHIBITION

CATALOGUE NUMBER 1

*A Short History of Modernist
Painting*, 1979–80
Oil on canvas
72 x 72 ins. (182.9 x 182.9 cm)
Eli Broad Family Foundation,
Santa Monica
(PAGE 15)

CATALOGUE NUMBER 2

The Innocent Eye Test, 1981
Oil on canvas
78 x 120 ins. (198.1 x 304.8 cm)
The Metropolitan Museum of
Art, New York, promised gift
of Charles Cowles, in honor of
William S. Lieberman, 1988
(PAGE 56)

CATALOGUE NUMBER 3

*Robbe-Grillet Cleansing Every
Object in Sight*, 1981
Oil and crayon on canvas
72 x 72¼ ins. (182.9 x 183.4 cm)
The Museum of Modern Art,
New York, gift of Mr. and Mrs.
Warren Brandt, 1982
(PAGE 38)

CATALOGUE NUMBER 4

Four Forbidden Senses, 1982
Oil on canvas
58 x 160 ins. (147.3 x 406.4 cm)
Eli Broad Family Foundation,
Santa Monica
(PAGES 34–35)

CATALOGUE NUMBER 5

Purity Test, 1982
Oil on canvas
72 x 96 ins. (182.9 x 243.8 cm)
Collection of The Chase
Manhattan Bank, N.A.
(PAGE 49)

CATALOGUE NUMBER 6

Iconograph 1, 1984
Oil on canvas
72 x 72 ins. (182.9 x 182.9 cm)
Courtesy of Curt Marcus
Gallery, New York
(PAGE 40)

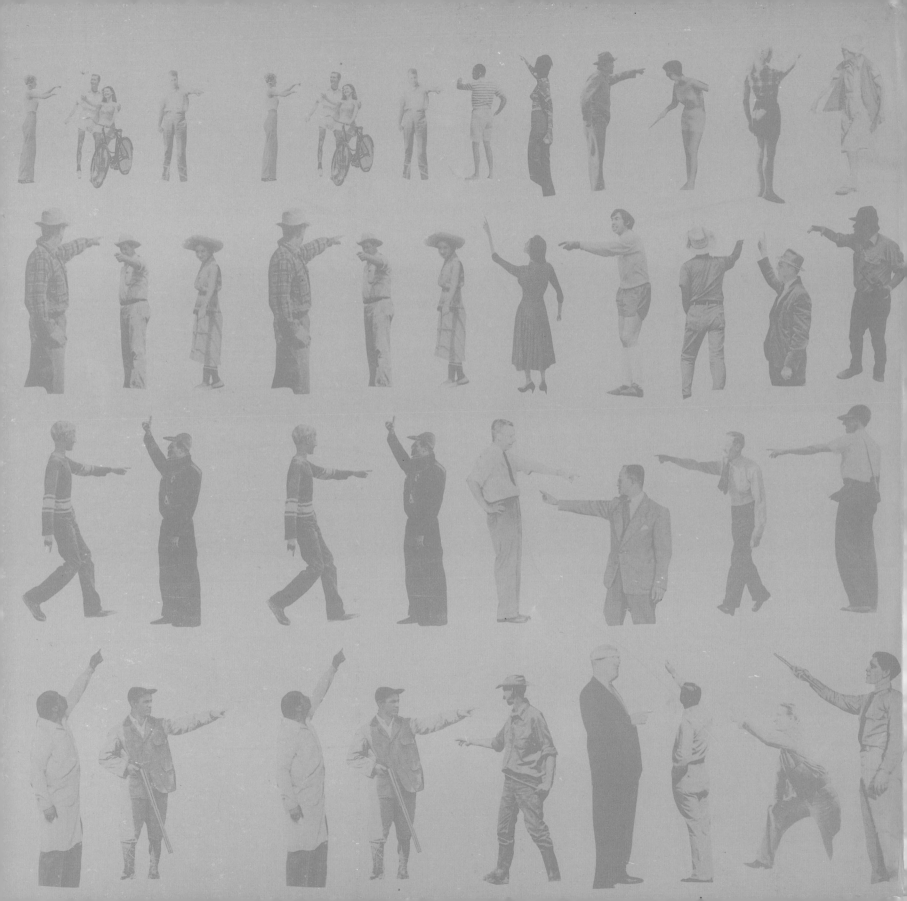